IMAGES
of America

IDYLLWILD AND THE
HIGH SAN JACINTOS

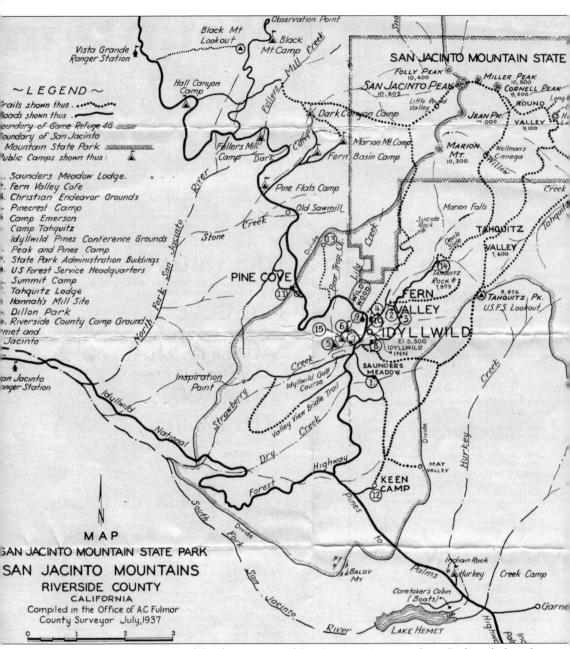

~ LEGEND ~

Trails shown thus . . . •••••••••
Roads shown thus . . .
Boundary of Game Refuge 4G ———
Boundary of San Jacinto
 Mountain State Park ××××××××××××××
Public Camps shown thus : ▲

1. Saunders Meadow Lodge.
2. Fern Valley Cafe
3. Christian Endeavor Grounds
4. Pinecrest Camp
5. Camp Emerson
6. Camp Tahquitz
7. Idyllwild Pines Conference Grounds
8. Peak and Pines Camp
9. State Park Administration Buildings
10. U.S. Forest Service Headquarters
11. Summit Camp
12. Tahquitz Lodge
13. Hannah's Mill Site
14. Dillon Park
15. Riverside County Camp Ground

MAP

SAN JACINTO MOUNTAIN STATE PARK

SAN JACINTO MOUNTAINS
RIVERSIDE COUNTY
CALIFORNIA
Compiled in the Office of A.C Fulmor
County Surveyor July, 1937

This 1937 map was prepared for the opening of San Jacinto Mountain State Park and identifies many locations referred to later in this volume. To picture the approximate extent of the "high San Jacintos," imagine a triangle formed by Lake Hemet (at bottom), Vista Grande (upper left), and Hidden Lake (upper right). (Idyllwild Area Historical Society.)

ON THE COVER: In August 1910, these campers from Banning stayed at "Kamper's Kingdom," a short-lived hunting camp located on Fuller Mill Creek. The camp proprietor and photographer was C. Beverly Hughes, who homesteaded at the site of Fuller's Mill, an early sawmill north of Pine Cove near Black Mountain in the high San Jacintos. (Idyllwild Area Historical Society.)

IMAGES
of America

IDYLLWILD AND THE HIGH SAN JACINTOS

Robert B. Smith
Idyllwild Area Historical Society

ARCADIA
PUBLISHING

Published by Arcadia Publishing
Charleston SC, Chicago IL, Portsmouth NH, San Francisco CA

Printed in the United States of America

Library of Congress Catalog Card Number: 2008931762

For all general information contact Arcadia Publishing at:
Telephone 843-853-2070
Fax 843-853-0044
E-mail sales@arcadiapublishing.com
For customer service and orders:
Toll-Free 1-888-313-2665

Visit us on the Internet at www.arcadiapublishing.com

*In memory of George Hannahs, Claudius Emerson, and Ernest
Maxwell, whose foresight, energy, and values shaped the San Jacinto
mountain communities.*

CONTENTS

ACKNOWLEDGMENTS

Unless otherwise noted, all images in this volume appear courtesy of the Idyllwild Area Historical Society (IAHS), without whose extensive archive this project would not have been attempted. Thanks especially to IAHS's founding curator Lynnda Hart, founding president Sheila Meyer, assistant curator Shirl Reid, and former board member Lynn Voorheis, the rich photographic history of the San Jacinto Mountains is being preserved.

The author is indebted to IAHS's countless donors, especially Carol Johnson Adamson, Marianne Bailiff, Terry Bauman, Ted Belden, Steve Carlson (Living Free), William Cooper, Sherry Hibbard, Joyce Miller, and Janice Sutton for providing access to original prints.

Banning Public Library director Patti Hanley went beyond the call of duty to ensure high-quality images from their local history collection. Steven Hudson of the Idyllwild Arts Foundation's Krone Museum, Betty Jo Dunham of the San Jacinto Valley Museum, and Pamela Hubbell of the Hemet Public Library helpfully offered their archives.

Images from two extraordinary IAHS collections, works of the distinguished Riverside photographer Avery Field and of Idyllwild postmaster and master photographer Harry Wendelken, are specifically noted wherever they appear.

IAHS is indebted to the Field family, particularly Avery's grandsons, Charles and Sid Field, for their generous donation of his original photographic negatives of mountain scenes and for permission to include these copyrighted images in this volume. Credit is due the *Idyllwild Town Crier*, Becky Clark (publisher and editor), and the Wendelken family, particularly Harry's daughter, Sandra Wendelken Smith, for the donation of Wendelken's original negatives.

No work of this scope proceeds without inspiration and reinforcement. Through their books, conversation, and advice, authors John Robinson and Steve Lech were godfathers to the project. Through her tutoring and example, Lynnda Hart encouraged the author to immerse himself in Idyllwild's past; she also reviewed the entire manuscript critically. Arcadia editor Debbie Seracini offered timely advice at crucial points. Most important, Adele Smith, the author's perennial companion, reinforcer, and copyeditor, played a key role in maintaining his sanity and ensuring a more readable and engaging product.

INTRODUCTION

Idyllwild nestles in Strawberry Valley, a mile high in the San Jacinto Mountains, barely 10 miles by air from the pincers of Southern California's sprawling suburbia, but a half-century removed in pace and character. Here one finds none of the fast-food emporia, tract houses, chain stores, freeways, and smog that have come to characterize life down below since World War II.

First-time visitors from the flatlands are amazed at the pervasive solitude of this forest-shrouded mountain village. New residents are struck by the friendliness and decency of folks they meet on their daily rounds at market, bank, post office, or refuse transfer station. There seems to be a shared sense that the sheer good fortune of living in such a favored place must be carefully stewarded through deeds of mutual regard and help.

Many longtime residents and visitors find a deeper connection with these mountains, which so dominate the community that from nearby vista points evidence of human occupation is practically invisible. The forested wilderness is close at hand yet rugged, demanding to be experienced on its own terms, not as some domesticated parkland. A mystical force enchants those who spend enough time wandering the surrounding heights, listening to the calming breezes and creeks, and breathing the crystalline air. It works on children, who find themselves drawn back repeatedly as adults, some eventually moving here permanently. The author is among them, having returned to the San Jacintos almost annually since 1939, never feeling quite fulfilled until settled permanently in Strawberry Valley.

What has formed such an extraordinary place and community? Why has this area so successfully resisted the development mania of contemporary mountain resorts?

Those questions underlie and animate the scenes explored visually in this volume. Answers may lie in the people, places, and events that draw the camera's attention, but its lens at the same time absorbs a surrounding fabric of landscape and mundane activity, within which character takes shape and history unfolds. To grasp the significance of a photograph, a viewer should attend to both.

A case can be made that the character of Strawberry Valley and its surroundings was gradually molded between about 1880 and 1960, along six dimensions reflected in this volume's six chapters.

The San Jacinto Mountains initially shared the fate of all Western forest lands. For centuries, this forest had supported native Cahuilla Indians with food and fiber gathered seasonally to supplement sparse desert resources. With the European immigration after 1860 came an industrial vision of natural riches to be exploited for vegetation, minerals, water, and lumber to support a changing Southern California economy. Although the local topography discouraged mining, ranching, and dam building at higher elevations, for many years, cattle and sheep were driven to summer pasture in high-altitude meadows, and construction of Hemet Dam in the 1890s helped make the high country more accessible. Until the 20th century, however, it was logging that dominated the higher slopes and canyons, especially in Strawberry Valley, the site of future Idyllwild.

After the first public road to Strawberry Valley opened in 1888, a trickle of campers following the wave of loggers became a flood. One timber entrepreneur, George Hannahs, soon saw a more promising long-term future in attracting visitors with campground amenities and lodging facilities. The campers' observation of rampant plundering by lumber companies, here as elsewhere in the West, helped galvanize Congress to authorize federal reserves. In 1897, Pres. Grover Cleveland

created the San Jacinto Forest Reserve to protect the vast majority of the range. Grazing, logging, and human habitation were permanently restrained, but pockets of private land remained, and a struggle to preserve the high country more fully continued into the 1950s. Throughout this period, which saw creation of both a state park wilderness and similar designation on part of the national forest, land use tilted from the economic to the recreational. The forest itself became a popular destination, and singular features like Tahquitz and Suicide Rocks became world-renowned among serious climbers.

In 1901, a growing cluster of tourist enterprises was officially designated "Idyllwild." With the simultaneous opening of the Idyllwild Sanatorium, tourism, buoyed by skillful marketing, began to thrive on a larger scale. Claudius Emerson's 1917 purchase of the Idyllwild Inn sparked a new era, with refined facilities and resort activities like golf and tennis attracting widespread attention throughout Southern California. This development, along with the introduction of motor vehicles, generated a demand for roads better than crude 19th-century wagon trails, to which county and federal governments responded, slowly but surely.

Emerson used his initial 1,000 acres to launch a decade of subdivision and construction. He seeded community stability with land grants to enterprises like organizational camps and conference grounds. He encouraged vacation cabins and a commercial infrastructure to attract and support a growing resident population. Thus the modern village of Idyllwild took shape. Then, between 1930 and 1945, the community gradually unraveled under stresses of economic depression, war, and fire.

Among mountain visitors and residents, there have always been some who sought more solitude than they could find in even a relatively undeveloped tourist center. Such an urge supported a popular resort at Keen Camp, near today's Mountain Center. The more adventurous sought out private enclaves scattered across the national forest or simply squatted in the high valleys, away from the growing influx of tourists.

Starting in the late 1940s, newly arrived newspaper publisher Ernest Maxwell, with his bent for community inspiration and environmental preservation, led Idyllwild to rebound. The village began to solidify a new identity in 1950, with the opening of the Idyllwild School of Music and the Arts. By the end of the 1950s, the future direction of Strawberry Valley as a magnet for artistic talent and lovers of the outdoors was in place.

On the surface, the mountain community may seem paradisiac, but it shares drawbacks of small towns everywhere: minimal goods and services, along with an excess of rumor and long memories. A degree of perpetual public chaos is exacerbated by the absence of any established local government. Potential substitutes—chamber of commerce, advisory councils to county officials, volunteer organizations, ad hoc alliances—wax and wane with passing issues. One result is that village life has tended to be sustained largely through the collaborative efforts of many, rather than the leadership of a few.

For this reason, and because the mountains' narrative history and prominent residents have been admirably chronicled already by John Robinson and Bruce Risher in their monumental book, The San Jacintos, the present volume focuses less on personalities and more on the environment they inhabited, the features they created, and the activity they generated.

The images in this volume are drawn largely from the rich photographic history of the San Jacinto Mountains archived by the Idyllwild Area Historical Society. Works of Avery Field, Harry Wendelken, and Ernest and Robert Gray predominate, as they collectively dominated visual documentation of Idyllwild's early- to mid-century evolution. But the reader will also find here many scenes recorded by less celebrated or anonymous mountain photographers. All were chosen to supplement, rather than duplicate, the existing literature; with rare exception, no image included here has appeared previously in any other widely distributed book.

One

RESOURCE
THE MOUNTAINS EXPLOITED

The San Jacinto Mountains, rising more abruptly than any other range in the 48 contiguous states, a knife-edge defining coastal Southern California's eastern horizon, command instant attention. Curiosity follows, and 19th-century pioneers who first made the effort to explore this mountain wilderness were impressed with its resources—they observed wood, water, wildlife, and vegetation and imagined mineral wealth.

Cahuilla Indians came first, centuries ago. Settled around bleak desert springs and oases, they treasured the variety of plants and animals here for the taking on mountain slopes. Annual expeditions during warmer seasons enriched their diet, health, and spirituality throughout the year.

As California's Gold Rush faltered, prospectors fanned out, reaching the San Jacintos by 1860. Letters and news stories hinted at promising discoveries, but the biggest mining story here was an 1896 scam giving rise to Kenworthy, a boomtown in Hemet (now Garner) Valley. By 1901, it was history, and although scattered mines have since been worked sporadically in the area, no bonanza ever materialized.

Drought in the 1850s nearly wiped out Southern California's major industry, cattle, sending surviving ranchers scurrying to higher elevations in search of summer forage. Thus they discovered Hemet Valley in 1861, and soon cattle were spending summers in the high country in and above Strawberry Valley. Meanwhile, expanding farms in the San Jacinto Valley far below sparked construction of Hemet Dam, creating in 1895 a major reservoir for storage and delivery of water to the valley.

But these intrusions were minor compared with logging, which left a permanent imprint on the San Jacintos. Precipitated by construction of a transcontinental rail line through San Gorgonio Pass in 1875, primitive wagon roads for logging crews snaked into the mountains from Cabazon and San Jacinto. Over the next quarter-century, sawmills at Strawberry Valley, Dutch Flat, Stone Creek, Fuller Mill Creek, and elsewhere sent to market a steady stream of lumber to accommodate families, businesses, and farm and orchard produce.

Eventually, the tree-cutting industry became a self-limiting enterprise, retreating completely from the mountains by the 1920s in the face of public backlash and declining profit.

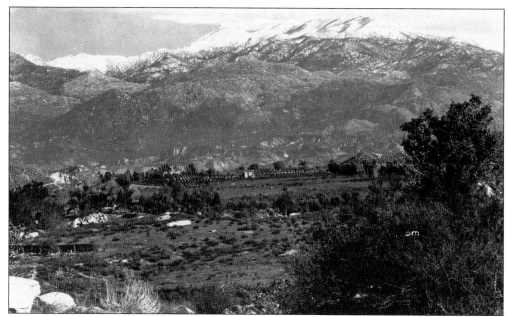

This 1920s view from near Hemet's Ramona Bowl contemplates the steep western face of the San Jacinto Mountains, shorn of foothills by the creeping San Jacinto Fault at their feet. From ancient Cahuilla Indian to modern suburbanite, summer visitors to these mountains have gazed through the winter at the often snow-capped mass beckoning them. And once having experienced the magic of the high San Jacintos, they do return. (Field Collection, IAHS.)

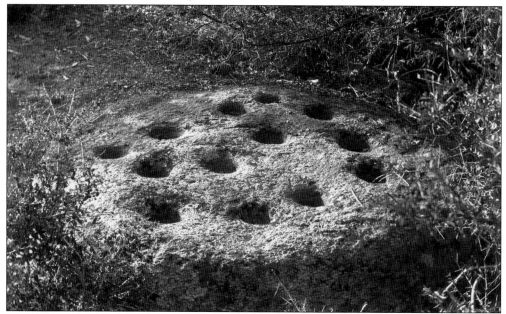

The former presence of Cahuilla (and perhaps Luiseño) Indians, the only humans known to have frequented the San Jacintos before 1860, is evident today in widely scattered pictographs and bedrock mortars. Such mortars often appear amid oaks, especially near water. As acorns were ground to meal, abrasion from hand-held stone pestles gradually smoothed depressions in granite into the symmetrical holes shown in this 1920s photograph. (Field Collection, IAHS.)

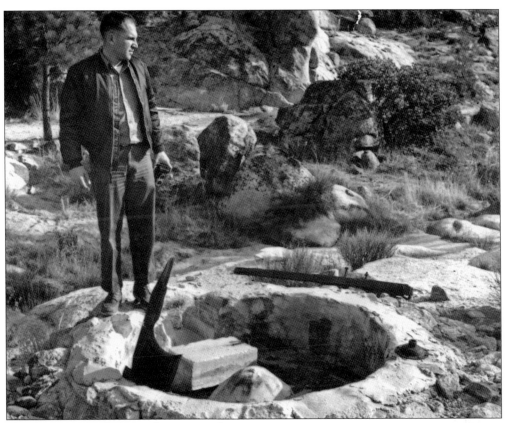

The disappointing history of mining in the San Jacintos between 1860 and 1900 left behind only scattered reminders of a once-frenzied enterprise. The arrastra here being documented by forest ranger Jim Ruppelt was found near the site of Kenworthy in Garner Valley. Its function was to separate gold from quartz by grinding ore finely under a heavy, flat, rotating stone, typically powered by a tethered animal walking around it.

After 1860, cattle grazed throughout the San Jacintos, but by 1900, a combination of expanding settlement in Strawberry Valley and federal forest preservation measures began restricting herds to lower elevations. Although the industry retreated largely to Garner and Anza Valleys, this view at Keen Camp as mid-century approached shows that remnants persisted above Lake Hemet.

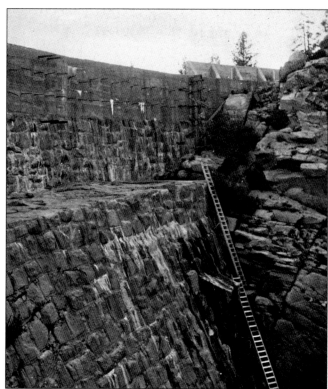

The quintessential industrial-scale enterprise of the 19th century in the San Jacintos was the construction of Hemet Dam (1891–1895). The ladders in this undated photograph lend scale to the granite blocks that constitute the structure, once the world's highest masonry dam. Project engineer Edward Mayberry's construction road created a second route from San Jacinto Valley into the mountains. The reservoir fed the new town of Hemet and surrounding farms.

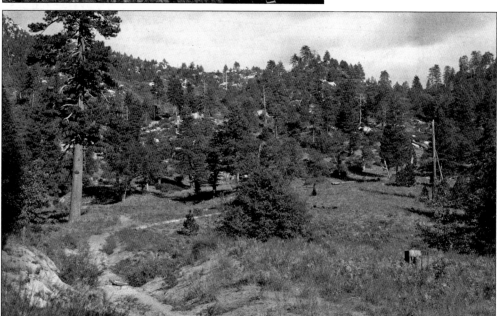

The first commercial logging camp in the San Jacintos operated briefly (1875–1877) on Indian Creek in what was called Little Strawberry Valley. Under contract with the Southern Pacific Railroad, Milton Hall's crews shipped railroad ties and locomotive firewood down to Cabazon. Some 35 years later, the area, known today as Hall Canyon, home to Lake Fulmor and the James Reserve, was slowly recovering.

Once a steep wagon road from San Jacinto Valley was cut in 1876, an abundance of gigantic trees like this incense cedar—note the adjacent automobile—quickly attracted loggers to Strawberry Valley. Somehow this specimen was preserved in the name of pioneer George Thomas during the early 1930s, only to have high winds finally topple it some two decades later. (Field Collection, IAHS.)

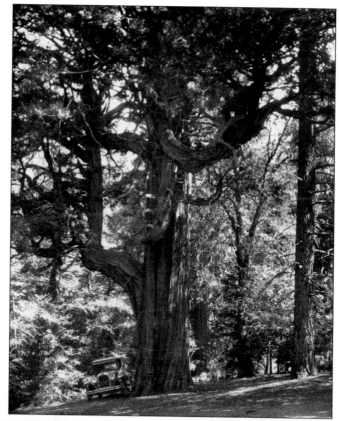

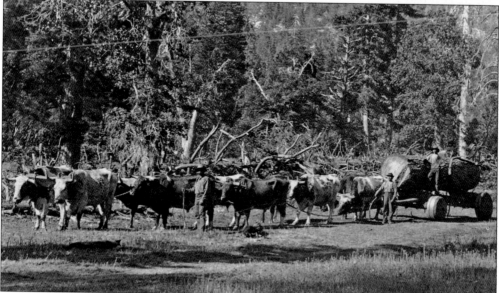

At first, primitive equipment—handsaws, wooden-wheeled oxcarts, water-driven mills—served to fell and dissect old-growth giants. The photograph is said to portray a crew working for Strawberry Valley's dominant logger, Anton Scherman, around 1884–1885. By the end of that century, a total of 4,000 acres in the valley had been cleared of commercial timber. (Field Collection, IAHS.)

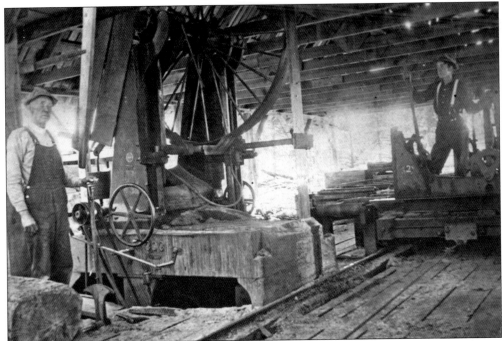

Early mountain sawmills were typically open-air sheds, roofed for protection from sun, rain, and snow but easily disassembled for relocation whenever the timber supply in the immediate area dwindled. This view of such a mill's interior shows the reciprocating head-saw blade in the center and, at the right, the moving bench on which logs were transported past the saw.

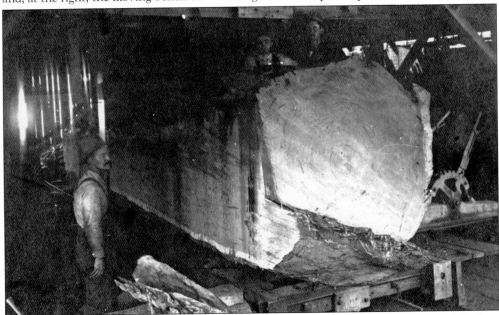

Although Strawberry Valley eventually became better known as a source of box wood for fruit crates, its larger trees helped fuel Southern California's first construction boom in the 1880s. This huge cedar is being milled on a rig similar to the one in the previous photograph. The facility was likely one of the Scherman family's mills.

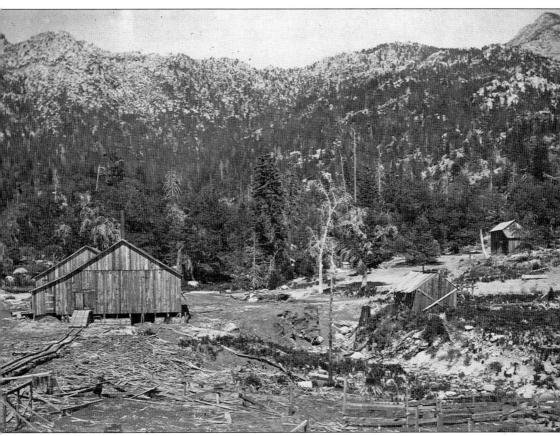

Fuller's Mill was a spin-off from Hall's operation, started by a man thought to be one of Hall's foremen who lugged a portable sawmill, piece by piece, to this spot in 1878 or 1879. A series of logging enterprises then appropriated and developed it to the state shown here shortly after its final abandonment in 1895. By then, the lumber from some 2,500 surrounding acres had traveled down a crude wagon road to the town of San Jacinto. The sawmill is at the left, its blacksmith shop at the far right, and dimly visible through the trees at the center of the picture is a one-room foreman's cabin. At the upper right, 10,450-foot Folly Peak looms over the scene, marking the western end of the highest ridge in the San Jacintos. Banning resident C. Beverly Hughes discovered the cabin as an ideal summer retreat in 1905; in 1910, he filed a 60-acre homestead claim. His spread would evolve into the rustic summer vacation community called Pinewood (see chapter five). (Banning Library District.)

As loggers exhausted the timber supply near a sawmill, they would often abandon camp and move the mill farther into the forest. Later, sites in the national forest were vacated under pressure from federal regulation. Abandoned camps attracted the curious, like this mule-riding group in the 1890s, its women outfitted in picturesque, conical straw hats. By 1920, only two sawmills, in Dark Canyon and Idyllwild, remained.

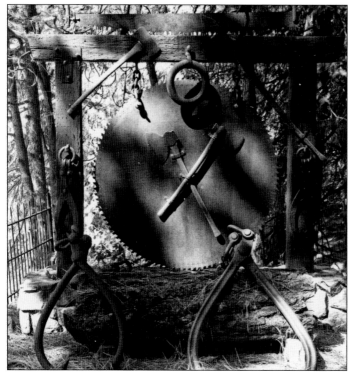

With industrial-scale logging now far beyond the personal memories of Strawberry Valley residents, its legacy is invoked only symbolically through mementos found scattered about the landscape or hoarded as household curiosities. The display of blades, tongs, and pike shown here was assembled in the eccentric collection known as the "Iron Garden," a continuing Idyllwild attraction. (Wendelken Collection, IAHS.)

Two

RESERVE
THE MOUNTAINS PRESERVED

As an intrepid few explored the high country on foot or horseback between 1860 and the early 1880s, they brought back accounts of a rugged but marvelous landscape. Once the crude toll road from Hemet became public in 1888, campers came to Strawberry Valley by the wagonload. Perhaps to constrain the growing flood of spectators, as well as to make a buck, a few loggers began to set aside space for them in primitive campgrounds. Others, like businessman-turned-logger George Hannahs, foresaw something far bigger.

The campers' enjoyment was diminished, however, by witnessing widespread removal of the forest. Already the boom of the 1880s around Los Angeles had prompted civic leaders concerned about preserving parks and watersheds to join counterparts throughout the West in urging Congress to authorize federal forest reserves. In 1891, they succeeded. Thus was planted a seed of lasting resistance to tree removal that would come back to haunt mountain communities in another century.

Following a systematic study of Western forests during the 1890s, Pres. Grover Cleveland proclaimed the San Jacinto Forest Reserve in 1897. This brought into the mountains a new cadre of public servants to manage the forest. By 1905, the U.S. Forest Service had taken permanent shape, and its rangers fanned out to patrol, protect, inform, plan, and supervise. Activity peaked during the Great Depression, as they oversaw massive construction of trails and camps by Civilian Conservation Corps workers.

Although decades would be required to eliminate habitual occupation of the high country by cattle, sheep, and saws, by the start of the 20th century, the tide of land use in the San Jacintos had begun to shift inexorably from exploitation to recreation.

And what opportunities for recreation the public found here! Commercial and public campgrounds multiplied. Riding and hiking expeditions blossomed. Fishing and hunting thrived. Rock climbers discovered fabulous granite walls. Swimming holes became a summer attraction, snow-covered slopes a winter lure.

The die was cast for Idyllwild's future as an outdoor recreational mecca, its basic asset the forest itself.

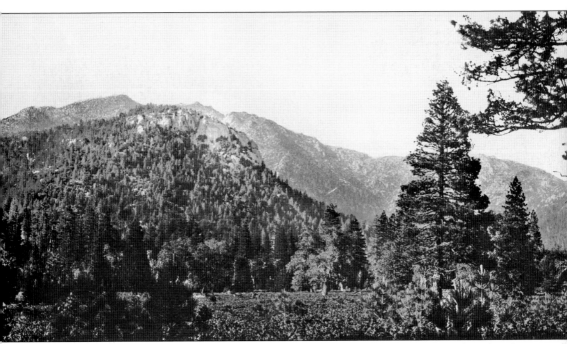

This panorama, seen from upper Strawberry Valley in the 1920s, captured the grandeur that first lured campers here. The fern-covered valley floor in the foreground lay at an elevation of 5,600 feet, its scattered pines and firs still recovering from 19th-century logging. In the middle ground, twin granite sentinels, Suicide Rock on the left and Lily Rock to the right, fashioned a gateway

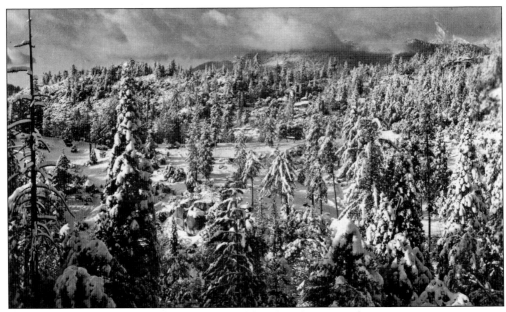

As settlers began to populate the San Jacintos, they found winter to be as picturesque a season as spring, summer, or fall. This early view of Dutch Flat, long before Foster Lake and its neighboring homes appeared, conveys the crisp chill after a storm, when clouds retreat from shrouded peaks and the sun first reappears. The area's name reflects logger Anton Scherman's German heritage.

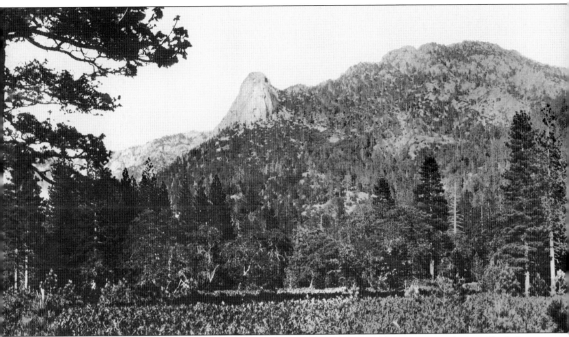

to the high country. Beyond Suicide Rock lay Marion Mountain, which at 10,382 feet marked the southern end of a ridge bearing the highest peaks in the range. Above Lily Rock stood 8,846-foot Tahquitz Peak, just a moderate day's hike from the village. Scenes like this continually remind local residents of their great fortune to live in such an inspiring place. (Field Collection, IAHS.)

Looking northeastward up Strawberry Valley, between Marion and Tahquitz peaks from a spur on South Ridge, revealed no sign of human occupation on the floor of Strawberry Valley in the 1920s, despite its logging history and a new development boom in full swing around Idyllwild village. Today, but for cabins built more recently on the spur in the foreground, the view remains remarkably similar. (Field Collection, IAHS.)

George Hannahs arrived in Strawberry Valley from Michigan in 1889. Although he went into partnership with Anton Scherman, Hannahs remained a businessman, not a career logger, and he quickly perceived the timber industry here to be a self-limiting enterprise. Tourism, on the other hand, promised a long-term future. Despite launching his own sawmill on upper Dutch Flat, Hannahs's prime energy went into lodging, camping, and retail enterprises.

After a year managing Strawberry Valley Lumber Company's primitive "hotel" for Anton Scherman, George Hannahs and his wife, Sarah, in 1891 opened "Camp Idylwilde" as an independent venture on the site of today's downtown Idyllwild. Two years later, his general store on Domenigoni Flat, where the road from Hemet entered the lower valley, became the area's first post office, Rayneta, with Hannahs as postmaster. (San Jacinto Valley Museum.)

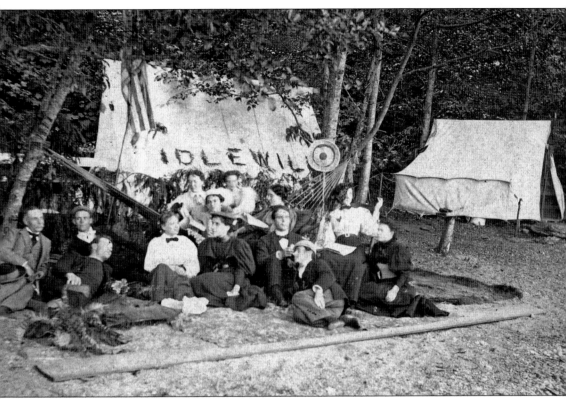

This group of campers typified Strawberry Valley in the 1890s, before large-scale lodgings sprouted. The vegetation suggests a creekside location, and the camp run by George and Sarah Hannahs was indeed bounded by Strawberry Creek, so this scene may well have been photographed at Camp Idylwilde. Among several variants of "Idyllwild" in use prior to 1901, "Idlewilde," which the group fashioned from fern fronds laid on the tent roof, seems a corruption of "Idylwilde." (The terminal "e" is inferred from notes on the back of this cabinet card and was apparently hidden behind what appears to be a dartboard.) Sketchy notes identified the campers, from left to right, only as "Mr. McCormick," Henry Ewing, Will Ewing, two unidentified, "Mr. Lyons," Will Comer, Nellie Comer, unidentified, "Mrs. Henry Ewing (Florence), Miss Glassgo, Miss Glassgo (sisters)," and Cora Comer.

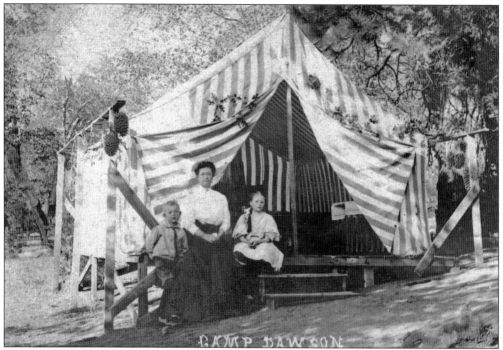

As time passed, commercial camping facilities around the new settlement of Idyllwild evolved from simple tents to more permanent "tent cabin" structures, consisting of a tent on a raised, wooden floor. "Camp Dawson," as seen on this 1907 postcard, was one of several now-forgotten tourist facilities around the dawn of the 20th century.

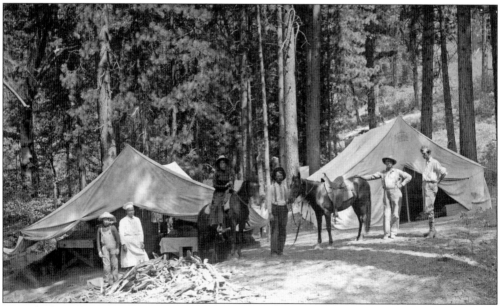

By 1910, less self-reliant campers could go on guided, overnight outings to a campsite set up for tours—note the wooden bed frame in the tent. On this occasion, it appears that Strawberry Valley's prime resort, the Idyllwild Inn, provided the services of its Chinese cook (second from left), who normally prepared meals for the inn's dining room clientele.

As morning light from the distant meadow filters through tall pines, firs, and cedars, a family camping at Riverside County Park enjoys a fresh-air breakfast. Much of the land for the park was given to the county in 1920 by Idyllwild Inn owner Claudius Emerson, and to this day, it operates essentially unchanged from the early days, when this photograph was taken. (Field Collection, IAHS.)

Local families and visitors to the San Jacintos wishing not to camp out but merely to enjoy a picnic in the woods have long found ideal escapes close at hand. One day in 1932, Idyllwild photographer Harry Wendelken, with his wife, Flo, and daughter, Sandra, did just that, enjoying the outdoors at a nearby campground, an occasion he preserved in this photograph. (Wendelken Collection, IAHS.)

As Americans took to the road again in postwar 1945, campers, like the rest of American society, began to acquire technological trappings. This once-hardy camper brought along some of the comforts of home: portable hot water heater, folding bathtub, and a roof over her head, not to mention that ubiquitous German import, the jerry can.

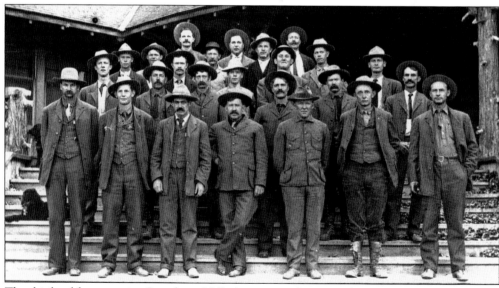

The chief tool for preserving Strawberry Valley's primitive character after 1897 was public ownership of the surrounding terrain. U.S. Forest Service rangers became the public's front-line custodians of the land. Rangers of the Cleveland National Forest, to which the San Jacinto reserve belonged briefly (1908–1925), met in conference periodically, and in 1910, they gathered at the Idyllwild Inn. (Laura Swift Collection, Hemet Public Library.)

A principal duty of early forest rangers, as today, was keeping watch for fire. Before a permanent lookout tower was built atop Black Mountain, a box of essential equipment was hung on a flag-bedecked pine log, propped upright among granite boulders. Evangeline Sumner (left) hiked up from Pinewood with an unidentified friend in 1924 and induced the ranger on duty to snap a picture.

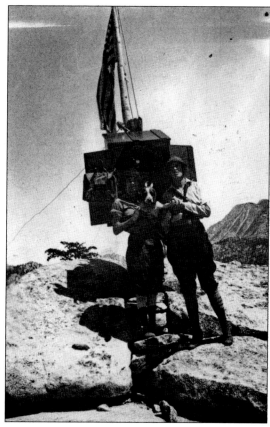

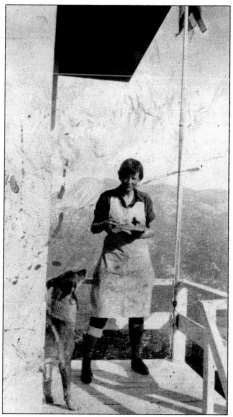

With San Jacinto Peak as a backdrop, ranger Rita Morris, the first woman hired for an outdoor job in the San Bernardino National Forest, dines on the deck of the Black Mountain tower, to the consternation of her impatient dog. Young women from nearby family cabins in Pinewood had befriended her and recorded this rare glimpse of daily life as a fire lookout in 1929.

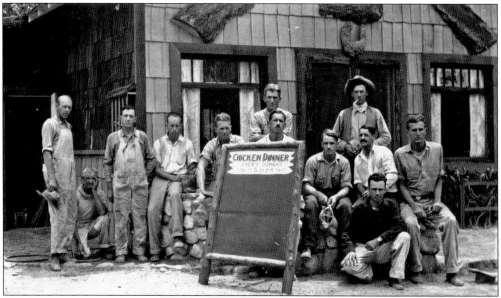

The Civilian Conservation Corps (CCC), the Great Depression's silver lining for the San Jacintos, built extensive recreation facilities during 1933–1937. CCC workers waiting here for the Rustic Tavern to serve Sunday chicken dinner include new recruit Jerry Johnson (dark shirt). Within days, he drove a new car to work, was promptly declared ineligible for welfare relief and fired, and instead became Idyllwild's leading postwar real estate developer.

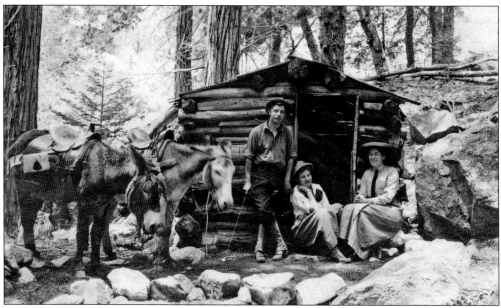

The San Jacintos' backcountry has been a prime attraction ever since its discovery by Cahuilla Indians. After 1860, drought-stricken ranchers from the valleys below came seeking summer pasture. To ease the rigors of dwelling on the ground, a few built crude cabins, which later became refuges for casual explorers. These dawn-of-the-20th-century women and their guide appear pleased to have discovered temporary shelter at one.

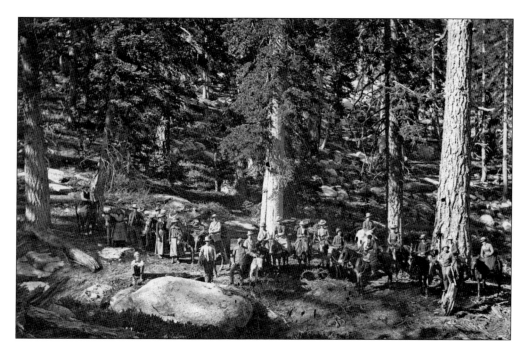

Dress conventions in the early days favored (and were likely perpetuated by) horseback as the way to travel into the San Jacinto wilderness. Riders from Banning in 1901 (above) paused for a portrait amid one of the impressive stands of old fir and pine scattered throughout the high country. Horses also gave early access to Hidden Lake (below), one of the high San Jacintos' special treasures, improbably perched at 8,800 feet atop a remote ridge. Depending on winter precipitation, the lake's appearance may range from a miniature Lake Tahoe to a shallow bowl of dried grass. Now protected as a fragile habitat, it no longer appears on maps, but in the early 1900s, it was a popular destination for groups like this one.

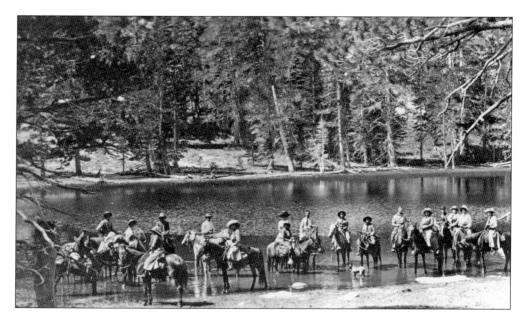

As the resort of Idyllwild developed, horses gradually became less prominent as a means of exploratory transportation to the backcountry, more often serving as an easygoing recreational amenity. Developed roads and nearby trails, especially out through Fern Valley, continued to beckon even casual riders (above). As this 1922 view suggests, however, a slow horse or inexpert rider could be left in the dust on occasion. By 1925, village stables regularly supplied a few hours of amusement to visitors and residents alike. Pausing in front of the Rustic Shop and Tavern (below), a combined gas station, restaurant, and furniture store, (today's Silver Pines Lodge) were locals, from left to right, Virginia Poates, Polly Holcomb, Jerry Johnson, proprietor Anna "Ma" Poates, Eleanor Poates (Johnson), and Veenie Miller.

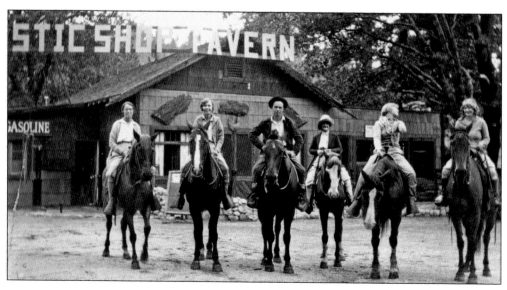

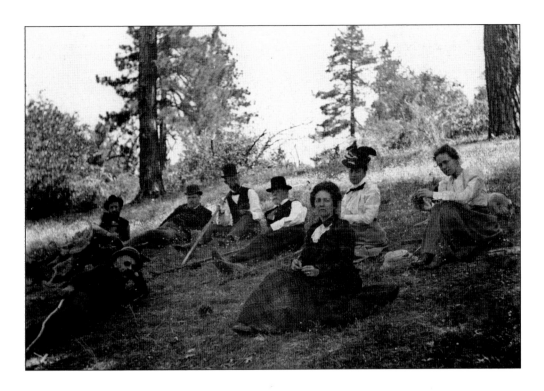

Hiking was undoubtedly strenuous in the 19th century, given the era's constraints of fashion and propriety. Having reached a shaded hillside (above), one party found lounging irresistible on the grassy slope beside the trail. A hardier group (below) negotiated the eight trail miles from Idyllwild to the desert overlook at Hidden Lake (although one suspects the involvement of equine assistance). Nicely silhouetted in the chill morning air at the brink of the San Jacintos' sheer desert escarpment, where the green forest around them gave way abruptly to the Coachella Valley's dust, sand, and rock, they must have marveled at the spectacular scene spread before them.

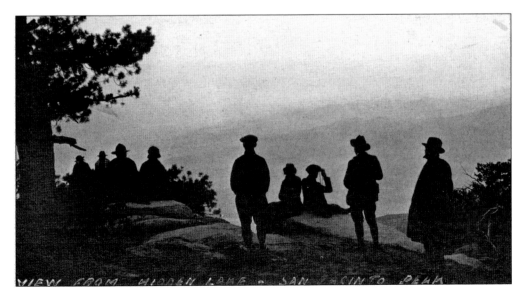

VIEW FROM HIDDEN LAKE — SAN JACINTO PEAK

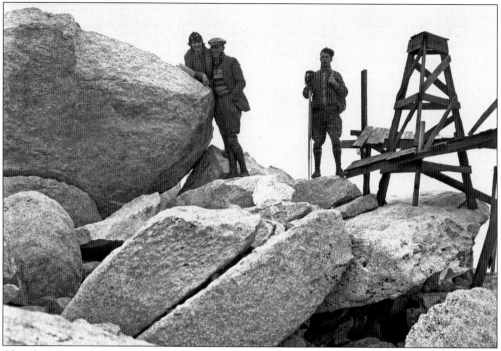

The ultimate goal of many hikers and mule- or horseback riders has always been the 10,834-foot, boulder-strewn summit of San Jacinto Peak. This trio of well-dressed hikers in the Roaring Twenties posed for the camera, documenting their accomplishment beside the remains of a triangulation platform built by government surveyors a half-century earlier. (Field Collection, IAHS.)

Whether an artifact of the Great Depression or simply expressing a long-term trend toward diminishing formality of style, hiking attire became steadily more casual. These two adventuresome women in 1931, pragmatically carrying canteens, blankets, food, and little else for an overnight hike, set out from Pinewood on Fuller Mill Creek to reach San Jacinto Peak via a primitive trace antedating the Seven Pines Trail.

With the postwar rebirth of Idyllwild's popularity, the informal Fern Valley trailhead that had served to deploy hikers during the first half of the 20th century regularly became overcrowded with vehicles. Law enforcement was called out to cite improperly parked cars. To relieve the congestion, the Humber family, who as sales agents had done much to populate Fern Valley, would donate the land now known as Humber Park.

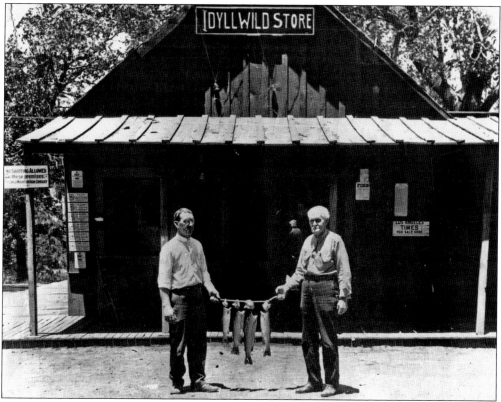

One reason for hiking was to reach a fishing hole, so the earliest Idyllwild store supplied fishermen as well as campers. This day's catch (around 1900–1910) was displayed in front of the store. The sign on the wall at the left warned against shooting on the premises; the one at the right invited more genteel customers to purchase the *Los Angeles Times*.

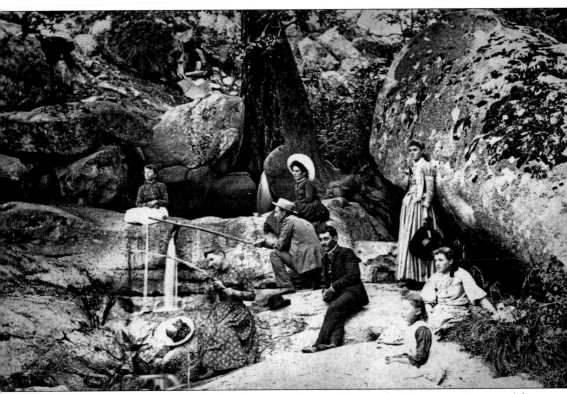

Fishing (or appearing to fish while relaxing to the soothing music of a mountain stream) has long been a Strawberry Valley attraction. But before mountain waterways were stocked regularly, the pickings could be slim. Nevertheless, all outings along the creeks carried a rewarding sense of adventure. Strawberry Creek's steep gradient from its source in a wetland high on the side of Marion Peak, the imposing boulders it has swept down from the heights through the eons, and its precipitous drop below Domenigoni Flat all contrast with its relatively gentle passage through the heart of the valley. According to notes on the back of the photograph, this typical 1890s group from San Jacinto Valley included, from left to right, (seated) Blanche McCormick, Kate Warner, Will Warner, Ada Strong, Charlie Long, and sisters Winnie and Minnie Sampson; (standing) Maud McCormick. (A second photograph of the same scene bears notes in a different hand identifying the location as "Lily Canyon" and the two girls in the right foreground not as the Sampsons, but as Blanche [left] and Maud Saunders!)

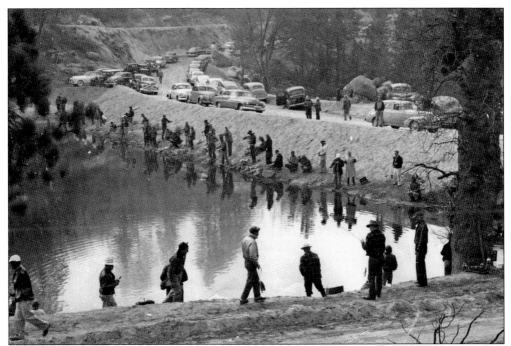

Opening day of the 1950 season attracted perhaps the largest crowd of fishermen in San Jacinto mountain history to inaugurate Lake Fulmor. Two abandoned segments of the old Banning-Idyllwild road, which since 1910 had conveyed traffic up Hall Canyon to the Indian Creek crossing and back, border the lake above the still unpaved shortcut that dammed the creek and created this new landmark along Highway 243.

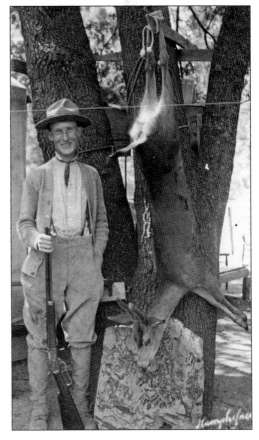

This pleased hunter posed proudly beside his rented Idyllwild tent cabin around 1910. From the time campers first discovered Strawberry Valley and the high country, hunting was a major attraction. The waxing and waning of the deer population and official efforts to control it remained a matter of considerable public debate through most of the 20th century.

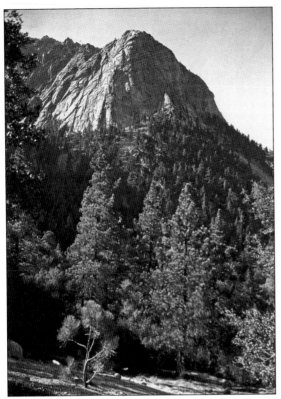

Strawberry Valley's earliest claim to global fame lay in iconic Lily Rock, better known worldwide as Tahquitz Rock. The name derives from Takwus, a mythical Cahuilla Indian troublemaker who usually appeared as a meteor or a human form emitting blue sparks but now dwells beneath the rock. Lily Rock's most striking view is from Devil's Slide Trail (left). In 1935, a budding Southern California mountaineering community chose the rock as an ideal climbing site, closer to home than the High Sierra. The standard Yosemite Decimal System for rating difficulty of climbing routes was actually invented here. Facing Lily Rock just across Strawberry Valley stands Suicide Rock (below), also a popular hiking and climbing destination once known as Council Rock. Pioneering climbers began developing routes on Suicide Rock in the 1960s. (Both, Field Collection, IAHS.)

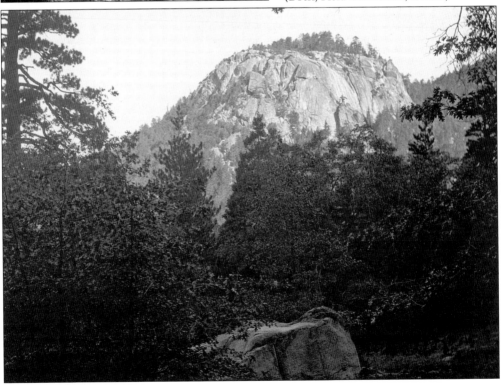

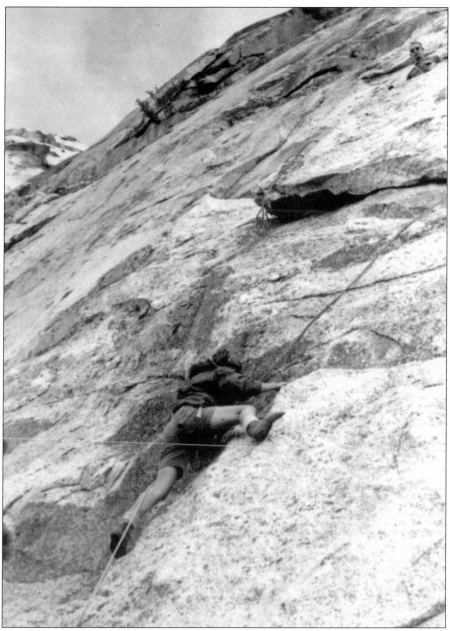

The fame of Idyllwild's twin towers was quickly established, and today the named climbing routes on the two rocks, all told, have grown beyond 500. Here early Idyllwild climber Jane Levy (foreground) negotiates Open Book on Tahquitz Rock, led by Royal Robbins. Robbins, born the year the rock was "discovered," developed his skills here before moving on to pioneering fame at Yosemite. He was perhaps the most creative and influential American of the mid-century era, a leader in changing climbing culture toward methods that minimize human impact on the wilderness, such as eliminating use of bolts and pitons. Tahquitz Rock has attracted other similarly adventurous celebrities: actor-filmmaker Erich von Stroheim, for example, chose the Idyllwild area for his 1919 directorial debut in *Blind Husbands* and set its climactic scenes on the sides and summit of the rock. (Jane Levy.)

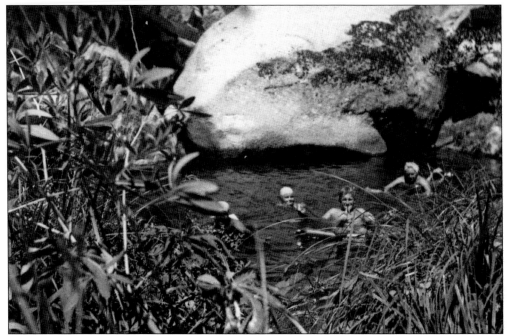

Hikers and vacationers at remote cabins had a knack for discovering favorite water holes in the icy mountain creeks. At a suitable pool, swimming, diving, sunbathing, and floating on inner tubes or air mattresses could fully occupy a warm summer afternoon. This 1949 photograph found a Pinewood family (from left to right, Sherry, Dick, and Evangeline Sumner Simpson) enjoying Fuller Mill Creek. (Sherry Hibbard.)

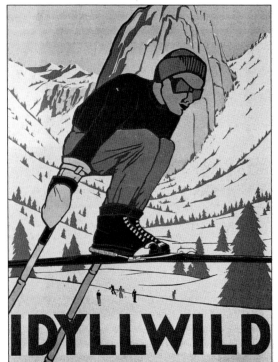

While Idyllwild has always been a magnet for summer recreation, its winter snows periodically spawned dreams of skiing in Strawberry Valley long before World War II. This forgotten poster, created by Thyrsis Field, a son of photographer Avery Field, was modeled on a photograph of his brother, Gaylor, sailing through the air wearing an "Idyllwild Ski Club" jacket. (Field Collection, IAHS.)

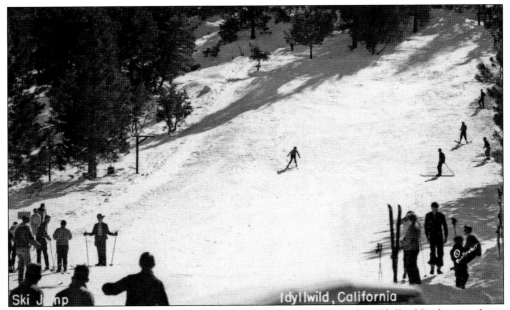

During its postwar surge, the American skiing industry knocked at Idyllwild's door without success, first at Hidden Lodge in Fern Valley. Then Halona Hill, near the upper end of Marion View Drive, gained popularity among residents and visitors, although the label "Ski Jump" on this postcard seemed to promise more than the modest hillside could deliver.

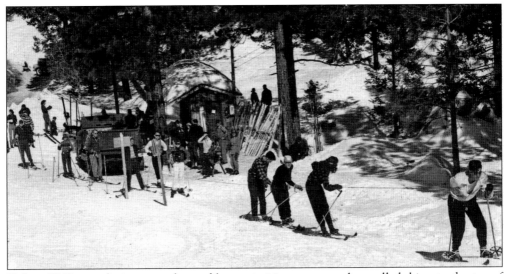

Halona Hill's popularity was enhanced by a primitive rope tow that pulled skiers to the top of the short run. This view shows the tow in use and a shed where rental skis were stored. The run was operated for several years during the early 1950s, before the land became more valuable as a cabin subdivision along today's Lookout Road.

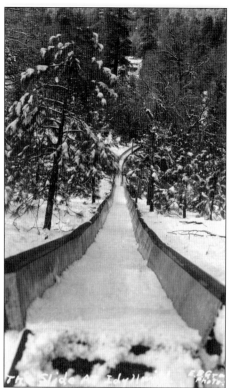

For residents, toboggans were the popular alternative to skis. On occasions when snow did pile up, this toboggan slide, simulating a bobsled run, could provide plenty of cheap thrills. It was built on the hillside above the Idyllwild School, and its constant upkeep exceeded infrequent rewards; it, too, was eventually abandoned.

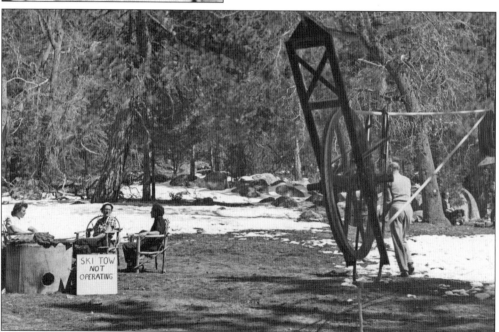

The sight of frustrated residents gathered at the foot of the Halona Hill rope tow, chatting in shirt-sleeve weather, epitomized the ultimate hurdle that faced each fleeting effort to commercialize skiing in Strawberry Valley: too little snow. Thus did Idyllwild escape the development pressures that have engulfed other mountain resorts.

Three

RESORT
THE MOUNTAINS REDISCOVERED

Although camping out was the way to experience the San Jacintos most intimately, by 1890, increasing traffic generated demand for more substantial lodging. Various "hotels" appeared, but the first substantial response was from experienced hoteliers John and Mary Keen of nearby Florida (today's Valle Vista). Their Keen House would reign as Strawberry Valley's leading hostelry for a dozen years.

Others came and went until Dr. Walter Lindley's fated Idyllwild Sanatorium greeted the new century. A financial failure that burned down in 1904, it was replaced by another unprofitable hotel, the Bungalow. Stockholders forced its sale to Los Angeles developers Frank Strong and George Dickinson, who renamed it the Idyllwild Inn.

Decent roads might have attracted a broader spectrum of visitors to this remote destination, but Joseph Crawford's 1876 road up from Oak Cliff in the San Jacinto River canyon bottom was a hastily constructed, narrow, diabolically steep wagon path. By 1900, a longer, slightly safer alternative existed, using part of Mayberry's 1891 road to Lake Hemet (page 12), but the debut of motor vehicles only worsened the ordeal of getting there.

Finally, in 1909, Riverside County completed the Old Idyllwild Road, a less precipitous realignment of Crawford's road. A year later, the first crude road linking Idyllwild with Banning opened. Strawberry Valley was poised for rediscovery.

Claudius Emerson's 1917 purchase of the Idyllwild Inn spurred a decade-long tourist boom that overloaded the roads from Hemet. The county intervened in 1921, restricting the Idyllwild and Keen Camp (Mayberry) roads to one-way traffic, with alternating times for uphill and downhill travel each day. This arrangement, which gave the Old Idyllwild Road its permanent nickname, "Control Road," persisted until 1929, when today's route between Oak Cliff and Idyllwild via Mountain Center opened.

Meanwhile, Emerson's elegant Idyllwild Inn had become the commercial and social center of Idyllwild. Ironically, the new Hemet highway was greeted, domino-like, by the crash, the Depression, and war. The Idyllwild Inn's glory days were past, and large-scale lodging, first introduced by Walter Lindley, would never recover.

In 1890, John and Mary Keen bought these buildings on the site of today's Idyllwild School, including early logger Amasa Saunders's home (far right). Here they opened the Keen House, Strawberry Valley's first enduring hotel. By 1901, massive new competition convinced them to relocate. They opened a new resort a few miles below Idyllwild (near today's Mountain Center) in 1905, calling it Keen Camp. (San Jacinto Valley Museum.)

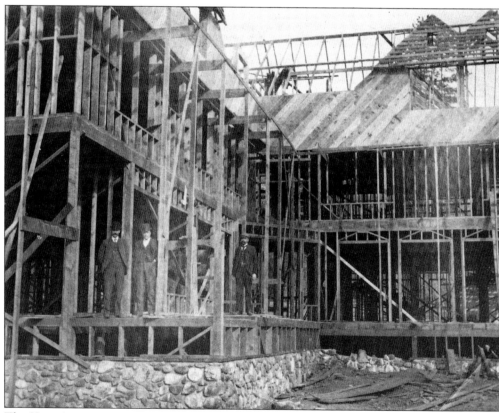

The Keens' new competitor was Dr. Walter Lindley, gynecology professor turned respiratory practitioner, who convinced himself during an 1899 camping trip that Strawberry Valley would be an ideal spot for tuberculosis patients. Incorporating as the California Health Resort Company, Lindley and colleagues bought more than 1,600 acres and began building on the site of Hannahs's Camp Idylwilde. Early in 1901, investors make an inspection tour of the rising Idyllwild Sanatorium.

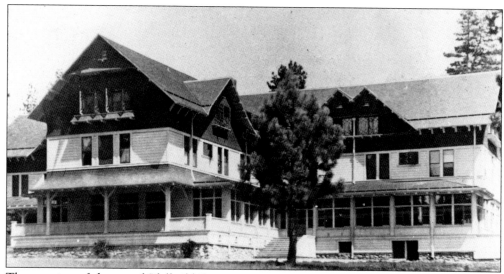

The opening of the grand Idyllwild Sanatorium in 1901 gave Strawberry Valley its first taste of large-scale tourism. Although planned and advertised as a medical treatment center, at the outset, a portion of the sanatorium served as a hotel. Possibly seen as a temporary way to finance the facility's operation until a steady medical clientele materialized, the combination proved financially disastrous.

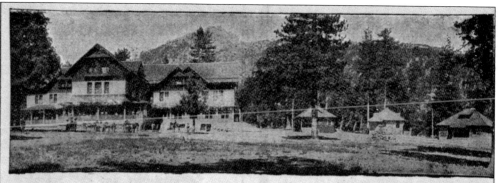

THE IDYLLWILD SANATORIUM

JUST ONE MILE
ABOVE THE SEA

IDYLLWILD-AMONG-THE-PINES, STRAWBERRY VALLEY
RIVERSIDE COUNTY, CALIFORNIA

Steam heat, electric light, modern plumbing, with mountain spring water piped throughout. Resident physician and corps of trained nurses. Nature's cure for asthma, la grippe, rheumatism, and all pulmonary diseases. 737,000 acres of pine forests. Grand mountain scenery. Furnished cottages and tents to rent for housekeeping.

Train (Santa Fe via Pasadena) leaves Los Angeles Tuesday, Thursday and Saturday, 8:30 a.m. Stage meets passengers at Hemet 12:40, arrives at Idyllwild at 5:30 p.m. For literature, write

R. A. LOWE, Manager, Idyllwild, Riverside Co., California.

LONG DISTANCE TELEPHONE

Walter Lindley badly misjudged Strawberry Valley's suitability for respiratory patients, but he did have a certain genius for marketing. From 1901, when the sanatorium opened, throughout the decade he owned or managed lodgings here, he put Idyllwild on the Southern California map. This advertisement in a 1902 edition of *Out West* magazine elaborated on transportation and accommodations.

The Alps of Southern California

IDYLLWILD

(one mile above the sea). A beautiful mountain village located in the midst of 737,000 acres of pine forest, is open all the year round. It is twenty miles from the Southern Pacific at Banning, and twenty miles from the Santa Fe at Hemet. Strawberry Valley Lodge, the principal hotel, has a chef who is unsurpassed. There is an orchestra, bowling alley, lawn tennis, billiards, hunting, excellent saddle-horses, and everything to make an outing delightful. Just the place for delicate children, overworked professional and business men, weary, nervous women, and all lovers of nature. Furnished cottages and furnished tents for rent for house-keeping to accommodate those who do not desire to board at the Lodge.

For particulars address

R. A. LOWE, Manager
IDYLLWILD, STRAWBERRY VALLEY
RIVERSIDE COUNTY, CALIFORNIA
Long Distance Telephone

A 1904 advertisement reflected the sanatorium's transformation, after two losing seasons, to Strawberry Valley Lodge. (The prior year's publicity had been explicit about excluding "tuberculous people" and eliminating "all Sanatorium features.") Unfortunately, the advertisement ran just before a dramatic midnight fire destroyed the nearly unoccupied main building. Manager Ralph Lowe had to flee for his life, but more widespread damage was precluded by a late-April snowstorm raging outside.

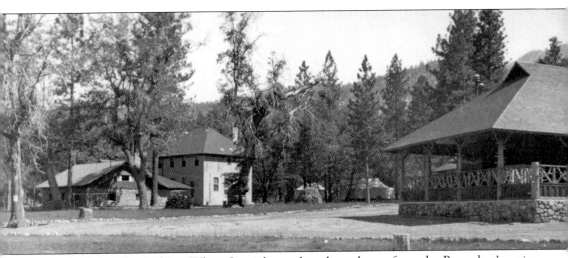

Fully loaded, "The Owl," or White Special, stood ready to depart from the Bungalow's main entrance on the morning run to Hemet. Inaugurated in 1906 with Ray Fobes as driver, the distinctive, white, custom-built stagecoach and team of white horses offered daily service to

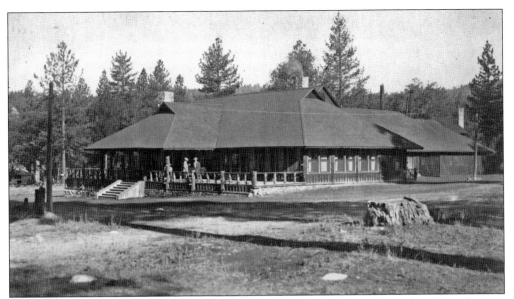

After the former sanatorium burned down in 1904, Walter Lindley quickly replaced it with a new hotel, which opened in 1905 as "The Bungalow." Here seen from its sunny ballroom entrance shortly after construction, it was built on the site now occupied by Jo'An's Restaurant. After disgruntled investors forced its sale to Frank Strong and George Dickinson in 1906, the budding resort would become the Idyllwild Inn.

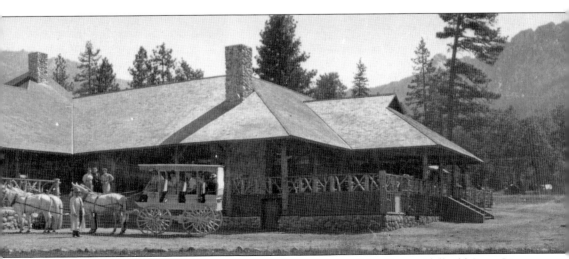

Idyllwild in only four and a half hours for upscale customers of the Hemet-Idyllwild Stage Line. (San Jacinto Valley Museum.)

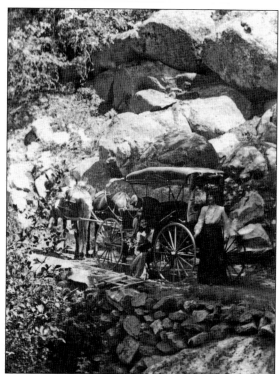

Many tourists and their trusty horses ventured up the treacherous Crawford Road on their own during the first decade of the 20th century. The steep, treeless climb from Oak Cliff was brutal for man and beast, so the first signs of shade as travelers neared the lower edge of the forest were cause for rest and rejoicing.

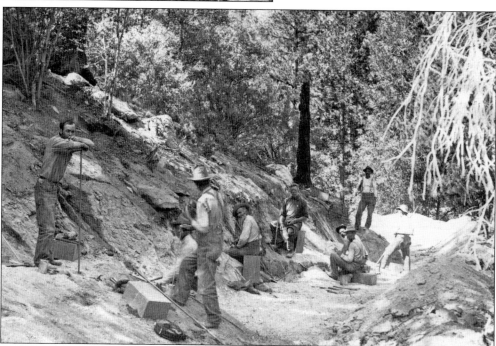

For three long summers (1908–1910), dynamite crews busily shattered solid granite to carve the first road from Banning to Idyllwild. Although by 1890 wagon roads had reached into the San Jacintos from the north and west as far as Fuller's Mill, and from the south to Strawberry Valley and Pine Cove, passage between these points was by foot or horseback only until August 1910.

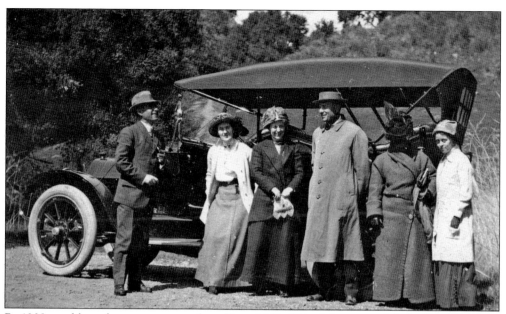

By 1908, weekly updates on stagecoach traffic to Idyllwild had disappeared from the pages of the *Hemet News*, superseded by increasingly frequent reports of excursions by touring car. Tourist parties like this unidentified group became a familiar sight. Well-dressed travelers often set out in high spirits from the flatlands, not fully realizing the ordeal that could await them on the slopes above.

The 1909 Old Idyllwild Road, later known as the "Control Road," snaked up from the San Jacinto River bottom at Oak Cliff. This view of its initial, unshaded climb, though recorded on a rainy day in the 1920s, readily conjures the discomforts of crawling up a dusty roadway under the broiling summer sun. That it represented great improvement over Crawford's 1876 route was scant comfort. (Field Collection, IAHS.)

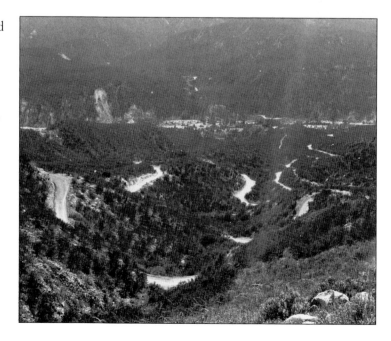

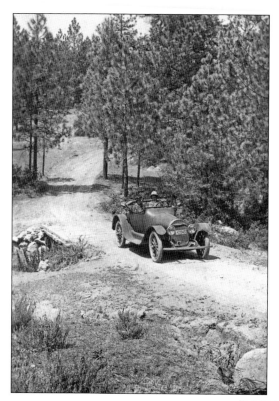

Travelers could bypass the Idyllwild Road by leaving Oak Cliff on the Mayberry Road, which had been built in 1891 to service Hemet Dam's construction. An 1899 cutoff to Idyllwild near Keen Camp, at the site of today's McCall Park (in Mountain Center), made this a somewhat gentler, but longer, drive. Clearly the so-called Keen Camp road could be relatively pleasant as it neared the junction.

After the steep climb from Oak Cliff to Halfway Spring, drivers on the Control Road encountered somewhat gentler terrain. Still, the roadbed itself was hardly benign. Storms could leave clay surfaces slippery, and mud developed deep ruts. The venerable Control Road has been preserved, however, and even today remains negotiable under favorable conditions in a suitable vehicle.

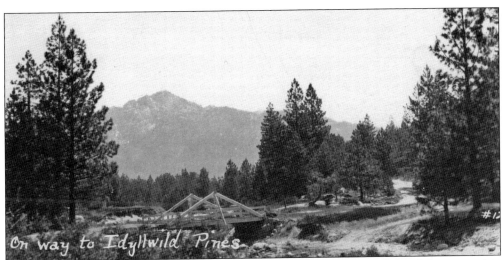

On way to Idyllwild Pines

With steep grades, endless switchback curves, and Control Road anxiety behind them, travelers approaching Idyllwild could finally relax and contemplate the magnificent view from Domenigoni Flat. The Strawberry Creek bridge served as gateway to the valley, as today it marks the entrance to the Idyllwild Arts campus. Unsurprisingly, Camp Idyllwild Pines appropriated this familiar view to publicize itself on a 1929 postcard.

209-ENTERING IDYLLWILD, CAL

Control Road travelers cruising up the gentle, wooded slopes just outside Idyllwild proper were relieved to anticipate the end of their long journey. Today this old route up Tollgate Road toward the village is a bypassed residential neighborhood, but motorists rounding the sharp curve on Highway 243 that now marks entry to Strawberry Valley feel a similar sense of arrival (or homecoming).

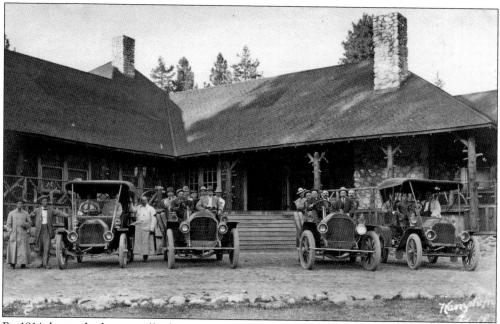

By 1914, horses had essentially disappeared in favor of internal-combustion engines. The auto stage now dominated commercial transportation to Strawberry Valley from both Hemet and Banning. But more and more tourists drove their own vehicles, often traveling in caravan. This photograph shows such a group as early as 1910, poised for departure from the main entrance of the Idyllwild Inn.

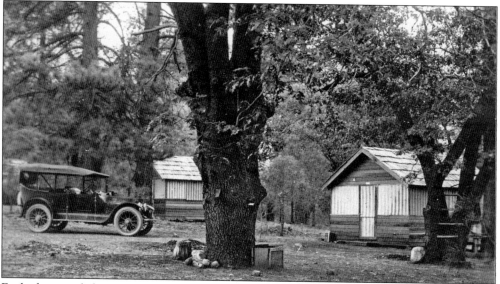

For budget-minded tourists, the next evolutionary step beyond the primitive tent cabin, which was merely a tent mounted on a platform, was a small but more substantial structure with screened walls covered by retractable canvas flaps. As automobile tourism began to flourish, cabins such as those seen here in 1918 spread through Strawberry Valley.

The developments of Claudius and Zelma Emerson at the Idyllwild Inn after 1917, as well as the popularity of Keen Camp's new Tahquitz Lodge (see pages 100–102), quickly overloaded the narrow mountain roads. To handle explosive traffic growth without making a major investment, the Riverside County Board of Supervisors took a drastic measure. During daylight hours, roads to Idyllwild and Keen Camp from Oak Cliff were restricted to one-way travel, with drivers allowed to proceed uphill or downhill only during specified, alternating periods. Roads were patrolled to enforce the rules. These provisions gave the old Idyllwild Road its permanent identity: "Control Road," the name still used on maps published today.

San Jacinto Mountain Control

(Effective May 29, 1925)

UP KEEN CAMP ROAD

Leave		Ar. Keen Camp Control Not Later than	
5:30	a.m.		6:30 a.m.
7:30	a.m.		8:30 a.m.
9:30	a.m.		10:30 a.m.
11:30	a.m.		2:30 p.m.
3:30	p.m.		4:30 p.m.
5:30	p.m.		6:30 p.m.
7:30	p.m.		8:30 p.m.
9:30	p.m.		6:30 a.m.

UP IDYLLWILD ROAD

Leave		Ar. Idyllwild Control Not Later than	
4:30	a.m.		6:00 a.m.
7:30	a.m.		9:00 a.m.
10:30	a.m.		12:00 p.m.
2:00	p.m.		3:30 p.m.
5:00	p.m.		6:30 p.m.
8:00	p.m.		9:30 p.m.
9:30	p.m.		6:00 a.m.

DOWN KEEN CAMP ROAD

Leave		Ar. Oak Cliff Control Not Later than	
6:30	a.m.		7:30 a.m.
8:30	a.m.		9:30 a.m.
10:30	a.m.		11:30 a.m.
2:30	p.m.		3:30 p.m.
4:30	p.m.		5:30 p.m.
6:30	p.m.		7:30 p.m.
8:30	p.m.		9:30 p.m.
9:30	p.m.		5:30 a.m.

DOWN IDYLLWILD ROAD

Leave		Ar. Oak Cliff Con. Not later	
6:00 a.m. to 6:30 a.m.			7:30 a.m.
9:00 a.m. to 9:30 a.m.			10:30 a.m.
12:30 p.m. to 1:00 p.m.			2:00 p.m.
3:30 p.m. to 4:00 p.m.			5:00 p.m.
6:30 p.m. to 7:00 p.m.			8:00 p.m.

BETWEEN IDYLLWILD CONTROL AND KEEN CAMP CONTROL

Leave Keen Camp Control each half hour beginning at 5:30 a. m., closing at 9:30 p.m.

Leave Idyllwild Control each hour, beginning at 5:00 a. m., closing at 9:00 p.m.

During the control hours drivers of vehicles may obtain permission from control operators to pass between Idyllwild Control and Keen Camp Control.

Vehicles may leave controls only at or between the hours stated and MUST arrive at next control NOT LATER than the time stated.

If unable to arrive at next control at stated time, vehicles MUST park, leaving roadway clear and wait until next control.

Vehicles may travel in either direction on these roads at any time between the hours of 9:30 p. m. and 4:30 a.m., but MUST conform to control between the hours of 4:30 a.m. and 9:30 p. m.

Speed limit is 15 miles per hour.

It is unlawful to leave rocks in the road after blocking vehicles.

Failure to observe these rules renders drivers liable to arrest.

Drivers please report any infraction of above rules to control officer.

**By Order of Board of Supervisors,
Riverside County.**

Ordinance No. 148.

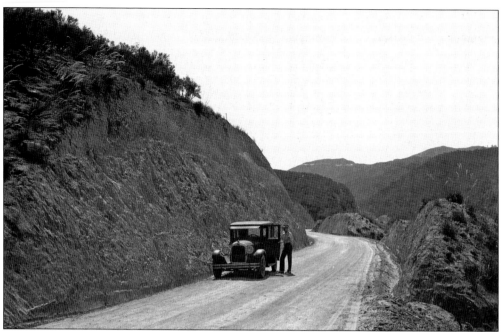

This was the scene above Oak Cliff in 1929, after travel between Hemet and Idyllwild was eased dramatically by the broad, well-graded, "high-gear" highway that retired the notorious Control Road. Generally paralleling Mayberry's early route to Hemet Dam as far as Keen Camp (Mountain Center), then winding its way up to Idyllwild, the new highway solidified the route travelers follow today. (Field Collection, IAHS.)

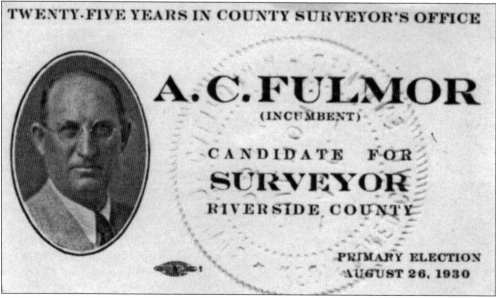

Behind nearly all Riverside County road planning and construction during the first half of the 20th century was county surveyor Alex C. Fulmor. Accusations of folly in his enthusiasm for road building were sometimes justified, as with his 1926 plan to connect Pine Cove with San Jacinto Peak. Usually, however, his planning prevailed, as was duly recognized in the 1949 naming of Lake Fulmor in his honor.

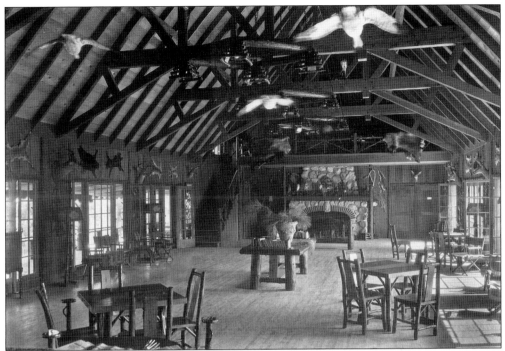

Anticipating increased tourism on the new highway, in 1928, Strong and Dickinson's local manager, Walter Wood, opened a new golf course on Saunders Meadow to compete with Emerson's course. The Mount San Jacinto Golf Club's clubhouse was liberally furnished with locally crafted rustic sofas, tables, chairs, ashtrays, floor lamps, banister, fireplace mantel, and massive chandelier. The building is now the Astrocamp dining hall. (Field Collection, IAHS.)

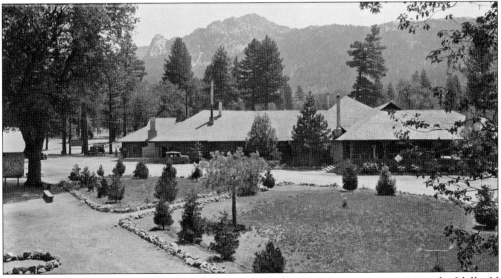

Entering its third decade as a local landmark, seemingly impervious to competition, the Idyllwild Inn settled into maturity as Strawberry Valley's dominant resort. An embryonic community was developing around it. Across the street (far left) stood the stone face of the Idyllwild Store and Post Office. Out of the picture to the left was the ever-popular swimming pool, the Idyllwild Plunge. (Field Collection, IAHS.)

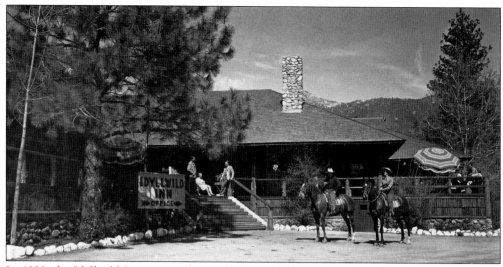

In 1929, the Idyllwild Inn was at the peak of its celebrity, as suggested by the sophistication of this staged publicity photograph. The Emersons had big plans for lower Strawberry Valley, damming the creeks for a lake and building a landing field for private airplanes. Then in October, the world changed abruptly, business collapsed, and by 1938, they had lost everything. (Field Collection, IAHS.)

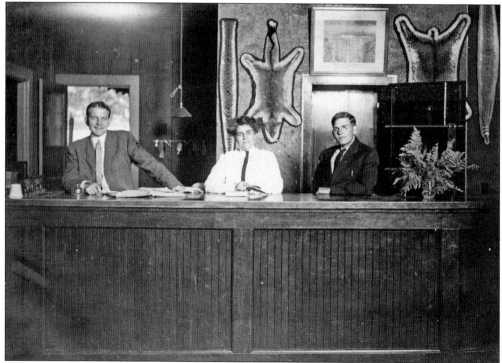

Exhausted motorists arriving at the Idyllwild Inn were greeted by the friendly staff at the reception desk, backed by souvenirs of local wildlife in this photograph from about 1910. By then, the resort had become known throughout Southern California as "Idyllwild Among the Pines," its popularity rising with completion of a new road from Banning that had been championed by the Southern Pacific Railroad.

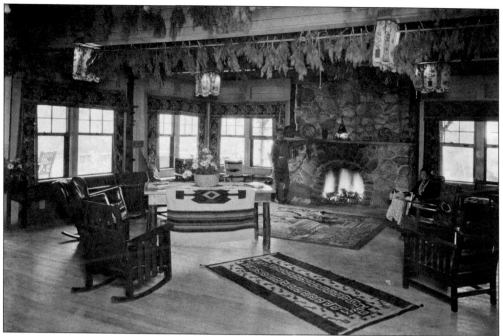

The Idyllwild Inn's interior embodied the elegance envisioned by Walter Lindley when he built the main bungalow. From the massive fireplace to the decorative, and no doubt fragrant, cedar fronds hanging from the ceiling, this lobby constantly reminded guests of the mountain environment they could enjoy just outdoors. (Field Collection, IAHS.)

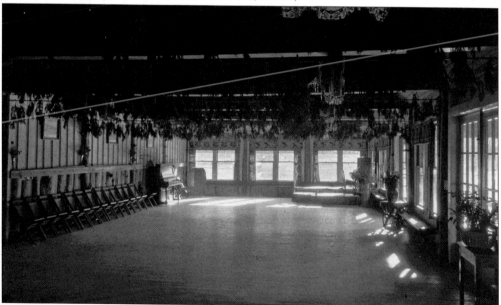

The Idyllwild Inn's ballroom was a popular gathering place for dances but also for masquerade parties, concerts, lectures, even trade shows. Even with the empty room bathed in the harsh light of the morning sun, it is not hard to imagine a festive atmosphere pervaded by the scent of the cedar ceiling trimmings, music from the bandstand, and hubbub of a Saturday night crowd. (Field Collection, IAHS.)

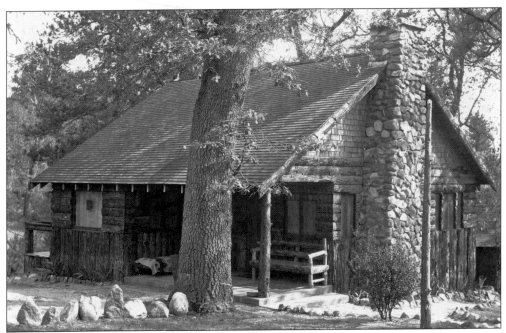

To supplement rooms in the main bungalow, the Idyllwild Inn accommodated guests in several satellite cottages and even did a brisk business renting space in its "tent city." In the late 1920s, the cottages were styled like many of Idyllwild's earliest vacation cabins, and this one perfectly reflects its surroundings. (Field Collection, IAHS.)

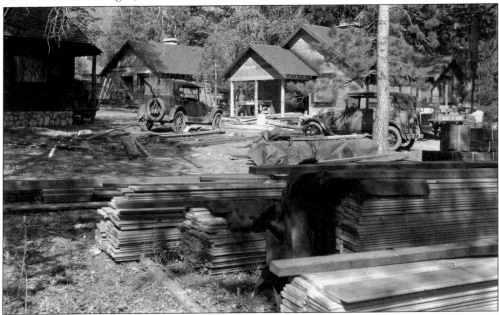

Although a handful of the Idyllwild Inn's cottages have survived more than a century, the property has undergone myriad changes, from bungalow to full-blown resort to motel. This c. 1930 flurry of new construction was on a site that will look familiar to today's visitors, but repeated demolition, construction, relocation, and remodeling make it nearly impossible to trace any particular structure's history. (Field Collection, IAHS.)

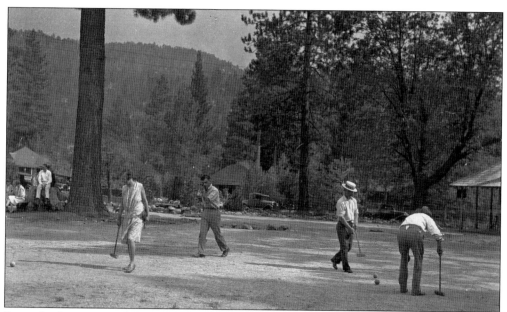

From the beginning of commercial tourism in the 1890s, croquet was a popular Strawberry Valley pastime. The Idyllwild Inn maintained a court on the spot where the Center of Idyllwild (commonly called "the Fort") stands today. Adjacent to the croquet court (out of the picture to the left) was the swimming pool, which generally monopolized spectators' attention. (Field Collection, IAHS.)

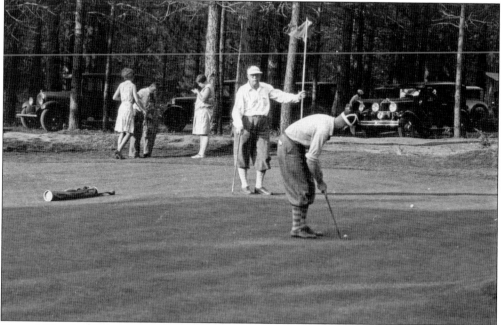

One of Claudius Emerson's first moves after buying the Idyllwild Inn in 1917 was to upgrade Idyllwild's earliest golf links. The Idyllwild Golf Club was a nine-hole course in lower Strawberry Valley stretching along the Control Road (now Tollgate Road). Despite its limitations, the course attracted statewide tournaments and casual golfers alike. (Field Collection, IAHS.)

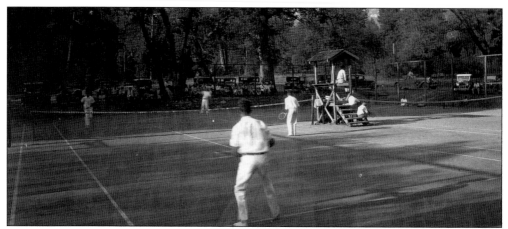

The Idyllwild Inn's tennis courts were laid out near the corner of today's North Circle Drive and Cedar Street. They offered recreation primarily for resort guests, but in their heyday, the Emersons also succeeded in attracting major Southern California tournaments. Such events did not guarantee a great crowd of spectators, but on occasion, the courts were surrounded by an impressive collection of the most elegant automobiles. These photographs capture the action (above) and the victors (below) in a 1929 tournament. The players are unidentified, but the picture offers a glimpse of both the clothing fashions and male dominance of the era. (Above and below, Field Collection, IAHS.)

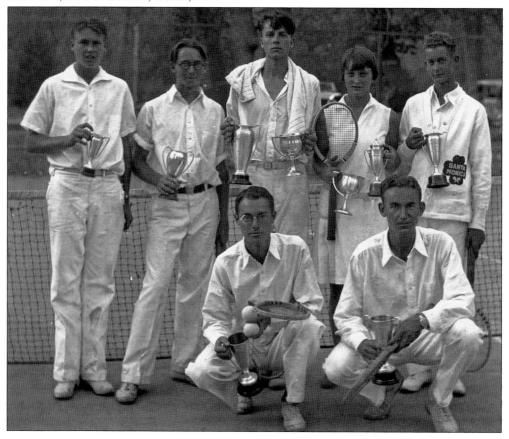

Claudius Emerson, formerly a San Jacinto banker, was the genius behind Idyllwild, Inc., the company he formed in 1917 to own, manage, and develop the Idyllwild Inn and surrounding 1,000 acres. The inn's daily operation was a family affair involving his wife, Zelma, and their children. In the winter of his career, he contemplates a bust of himself sculpted in ice by local artist Lora Steere.

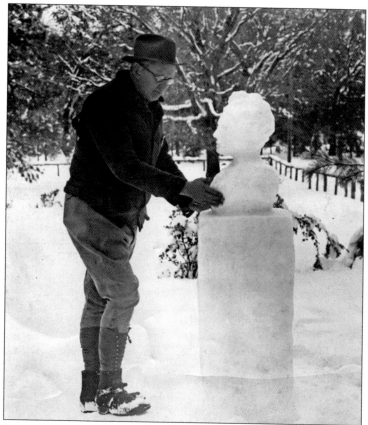

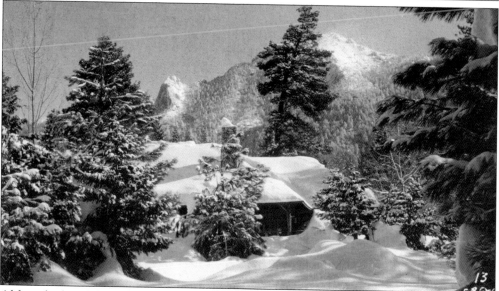

Although the Idyllwild Inn was widely known as a popular summer resort, under Claudius Emerson's ownership, it had become a year-round operation. Surrounded with maturing pines in its later years, it lay buried in white after a heavy winter storm, while Lily Rock and Tahquitz Peak provided a picturesque backdrop.

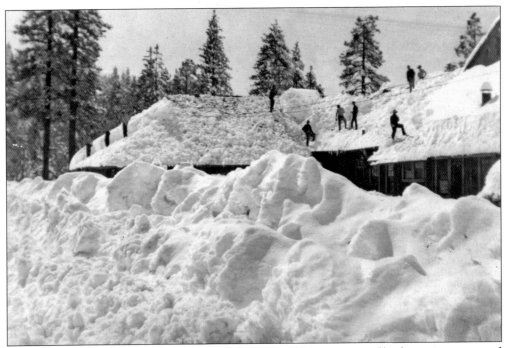

For all their beauty, snowstorms challenged the Idyllwild Inn in terms of both tourist access and building. To forestall damage from a heavy snow load, this 11-man crew went to work on the roof, adding to the white mountain already created by a snowplow. Such snow depth is rare nowadays, although winter still can supply the same beauty.

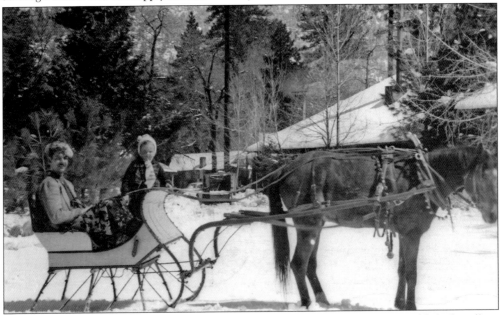

The challenge of getting around the village in winter could be made more enjoyable by bundling up in a sleigh, and the Idyllwild Inn offered sleigh rides. In fact, during the 1940s, some families actually depended upon such a horse-drawn vehicle, which they would board at Mountain Center in order to reach their Idyllwild cabins after a storm.

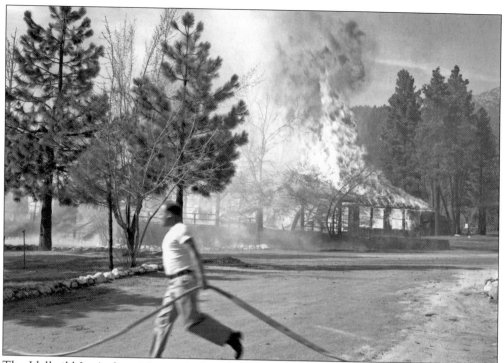

The Idyllwild Inn's slow, 15-year decline from celebrity to neglect ended quickly one sunny May afternoon in 1945, when the iconic bungalow suddenly caught fire. Volunteer firefighters responded energetically, but the flames had a head start. Delivering a fate common to wooden structures in a dry mountain climate, the inferno's fury overwhelmed all human effort. (Wendelken Collection, IAHS.)

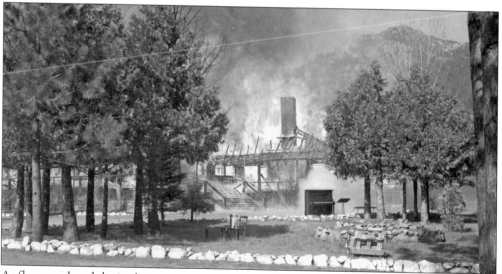

As flames reduced the inn's main entrance to ash, a solitary piano, bench, and music stand in the driveway seemed poignantly awaiting a recital never to be performed. Scattered about the lawn sat rescued pieces of local craftsman furniture, destined now only to become valuable items for future collectors. Thus ended the Idyllwild Inn's 40-year reign as the village's social and economic centerpiece. (Wendelken Collection, IAHS.)

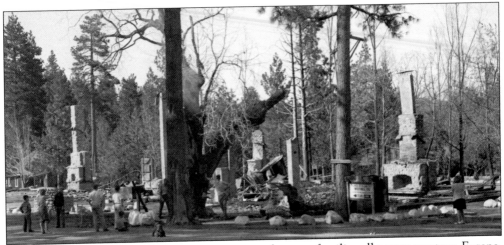

Throughout the following day, in a scene soon to become familiar all across war-torn Europe, Idyllwild residents came to pay their respects, standing quietly before the inn's still smoldering ruins. The looming chimneys, like massive headstones, gave the site the feel of a cemetery. The proud inn's destruction, on the heels of rescue from bankruptcy, marked the low point in Idyllwild village history. (Wendelken Collection, IAHS.)

During the summer of 1945, even as local citizens celebrated the end of World War II, they tackled the sad job of erasing all traces of the grand old Idyllwild Inn. This left a void both physical and spiritual in the heart of Idyllwild, one that could hardly be filled by the pathetic carnival rides that occupied the site over Labor Day weekend. (Wendelken Collection, IAHS.)

Four

RESIDENCE
THE VILLAGE EMERGES

While Claudius Emerson's development of the Idyllwild Inn solidified Strawberry Valley's resort image, what he did with his surrounding 1,000 acres, plus other land acquired after 1917, would give birth to Idyllwild as a real community.

George Hannahs yet again had been the pioneer who in 1913 began subdividing his substantial holdings into small lots for vacation cabins. But Emerson's Idyllwild, Inc., went at it in a big way, aggressively marketing lots that would become the core of a new village. Furthermore, he gave away substantial tracts, either as outright grants or at reduced prices, to attract stable enterprises he hoped would bring a steady stream of visitors and stimulate growth of a commercial infrastructure.

Thus began Idyllwild's first and largest industry, the operation of organized summer camps, which would give many thousands their first taste of the San Jacinto Mountains. Scouting and religious camps were Emerson's primary interest, but individual entrepreneurs realized there were other niches to fill. Eventually the area would see more than 20 camps established, most of which remain in operation to this day, some on a year-round basis. Another imported industry came from Hollywood, which has maintained a modest, but persistent, presence here since 1914, filming in locations from Garner Valley to Strawberry Valley.

Such businesses, together with the vacationers who regularly visited their own cabins, did help support commercial enterprises in the village. One unique, home-grown industry was the production of craftsman furniture from local timber, which burgeoned in the late 1930s.

As throughout Southern California generally, the early 1920s were boom years for Idyllwild, and by 1930, the resident population had reached 1,235. Then all came to a halt as the stock market crash and ensuing Great Depression put a damper on the economy. World War II with its travel restrictions dealt the final blow. Limited mostly to military visitors, the tourist trade, Idyllwild's life blood, diminished to a trickle, and the resident population plummeted below 450.

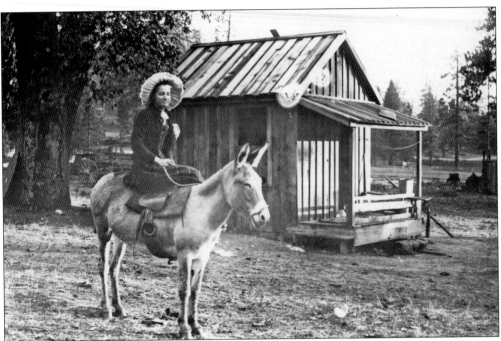

Strawberry Valley's first permanent dwellers may have begun settling in the late 1860s, but the earliest homesteads date to 1871, when the landscape became a checkerboard of public and railroad lands. The first dwellings were small, simple structures, little more than a shack (above), many of them similar in design and finish to the cabin in this 1894 photograph. Atop the burro is Kate Warner, a frequent visitor to the valley from San Jacinto. The more elaborate turn-of-the-century frame building (below), under construction on a grassy hillside, may have been a duplex, as suggested by its twin doors.

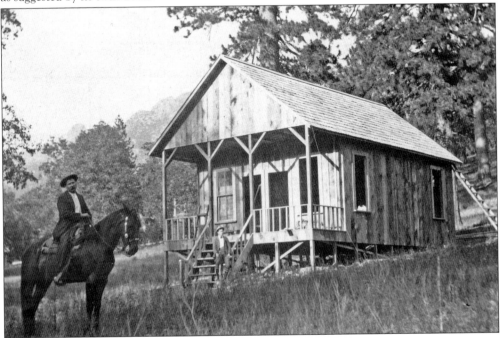

Another common design in the 19th century was the simple log cabin. This one was built around 1890 by Strawberry Valley's foremost logging operator, Anton Scherman. Still standing in the shade of ancient oaks and cedar on South Circle Drive, it is probably the oldest structure in Idyllwild today.

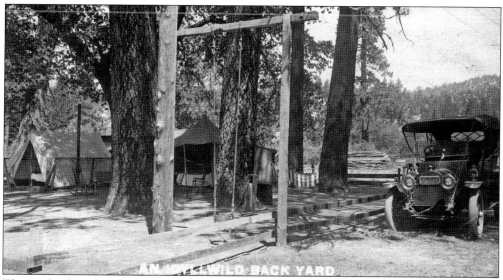

The misleading (or playful) inscription "Idyllwild back yard" referred to a Ballreich family home that did not yet exist. Trees were cut and the lumber milled on-site for eight years to produce one of Idyllwild's most elaborately rustic homes in 1928. Friends helped out, living in the tent cabins for months at a time, but the rocking chairs suggest that living conditions were not wholly spartan.

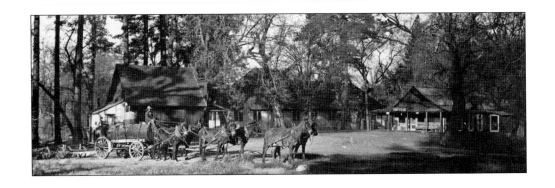

At the dawn of the 20th century, as construction of the Idyllwild Sanatorium drew the focus of activity up Strawberry Valley from Rayneta, a new store and post office became the hub of commercial activity. The building that housed these functions during the first decade of the new century at one point (above) bore a sign proclaiming "Post Office" and later (below) "Idyllwild Store." Early in the decade freight shippers still relied on horses for the heavy lifting, such as shipment of the boiler shown above. As automobiles proliferated, the store appeared to evolve toward being the valley's first automotive garage as well. Serving campers and sportsmen, as well as residents and lodgers, it was acquired in 1906 along with the Bungalow by developers Strong and Dickinson.

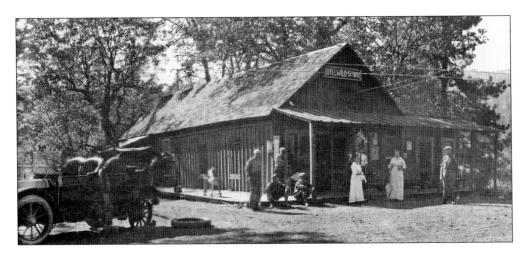

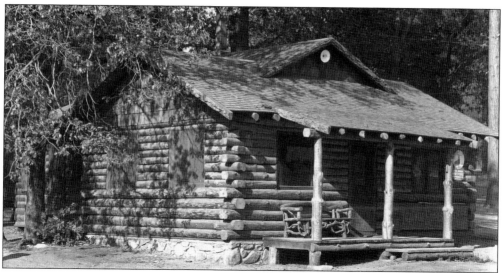

Nerve center for Claudius Emerson's development was the office of Idyllwild, Inc., across the street from the Idyllwild Inn. Here subdivided lots and insurance policies were sold for the vacation cabins and homes that became the core of the village. The familiar log cabin still stands at the pedestrian crosswalk on North Circle Drive, and it still serves as a real estate office. (Field Collection, IAHS.)

Once Claudius Emerson took charge of the Idyllwild Inn, he set out to build Idyllwild into a community. One project toward that goal was to publish a newspaper, *Idyllwild Breezes*, which appeared regularly from 1919 to 1929. It chronicled village visitors and happenings for residents and tourists alike. It could also fulfill other traditional uses of newsprint. (Field Collection, IAHS.)

This cabin, christened Glenwood Lodge, illustrated a common style of Idyllwild cabin in the boom era. Similar to several Idyllwild Inn cottages but built on wooden piers rather than a stone foundation, clad in cedar shingles, and trimmed with native tree limbs, it harmonized well with the mountain landscape. (Field Collection, IAHS.)

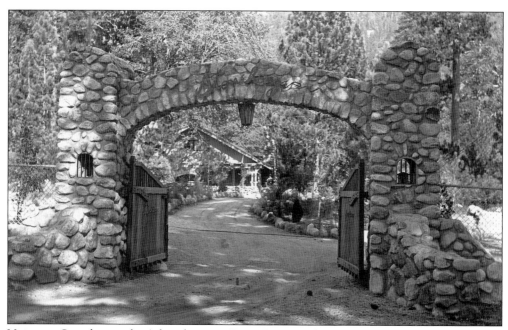

Visitors to Stonehenge, the Atkins home on River Drive, in the 1920s were greeted at the street by this elegant gateway built from local river rock. Such construction was once standard in Idyllwild for fireplaces and chimneys, foundations, retaining walls, and even some building walls. This gateway is still in place, essentially unchanged after nearly a century. (Field Collection, IAHS.)

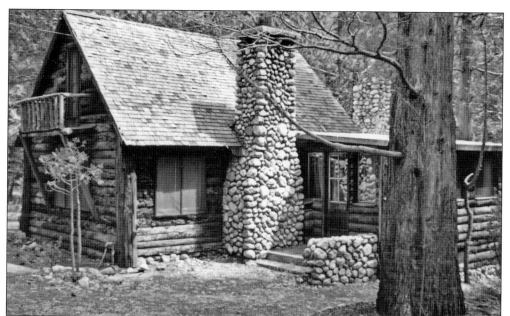

Typical of many older Idyllwild structures, this cabin, sided with bark-bearing timbers, illustrated river rock's versatility. Built during the surge of subdivision after 1917, it was still unoccupied when the Cole family from Long Beach bought it in 1923, calling it Eloc Lodge, a play on the family name. On a cold day the following year, they posed with friends, the Dickinsons, before an old black oak at streetside (right). Appearing are, from left to right, ? Dickinson, A. W. Cole, Victor Cole, Frances Cole, Louise Cole, and ? Dickinson. The poem above them, excerpted from Arthur Chapman's well-known cowboy poem, "Out Where the West Begins," was burned by Frances into a slab of scrap cedar. Louise's collected memorabilia paint the richest available portrait of daily life in early Idyllwild. The property remains in the family today.

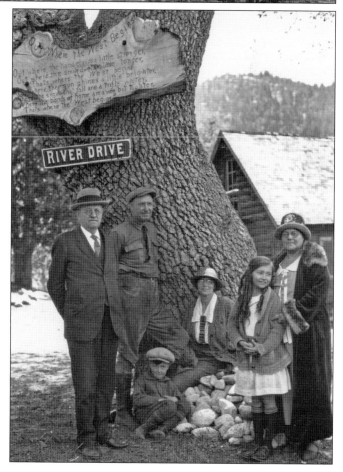

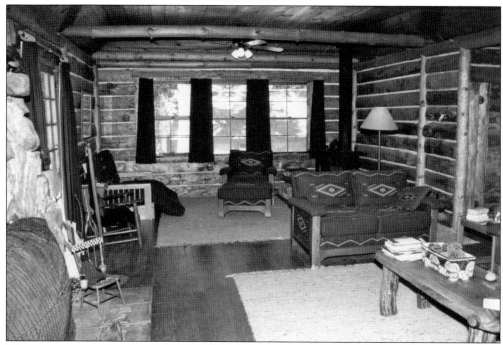

This interior view of another early-1920s log cabin conveys a feeling both woodsy and spacious. The cabin was built for the family of Palm Springs real estate agent John Munholland. The rounded object in the lower left corner is a large metal screen covering the mouth of a gigantic fireplace.

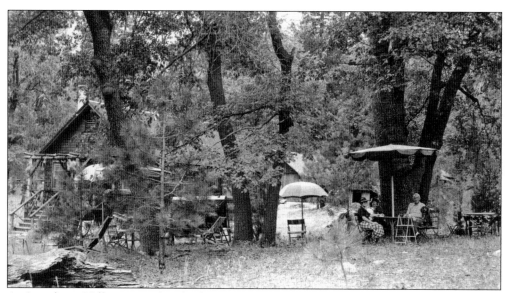

As Strawberry Valley accumulated cabins, clear mountain air and mild temperatures continued to draw people outdoors. Mr. and Mrs. W. J. Barlows were well equipped at their Woodpecker Cottage to pass lazy summer days in the 1930s, enjoying the outdoors in the shade of oaks and umbrellas. Here they entertain a friend, Mrs. Fletcher, and their dogs, Rosso and Gino. (Mr. Barlows failed to specify exactly who was who.)

In 1933, the William Butts family bought and expanded a two-room 1923 cabin on one of Emerson's Circle Drive lots. During one of the nearly 60 summers they spent here, Judy and Billy Butts posed on the patio with their father (above). Summer sleeping outdoors, by choice or necessity, was delightful in Idyllwild's early days, even on what is now busy North Circle Drive. Judy Butts sat in her modified treehouse (below), which was actually a small tent cabin on a raised platform behind the main family cabin, amply appointed with a bed, curtains all around, and faucets and sink installed by her father. Well preserved, this is one old cabin accessible to the public, as it now serves, together with its remodeled garage, to house the museum and office of the Idyllwild Area Historical Society.

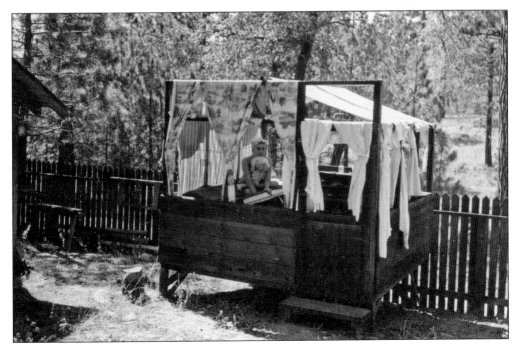

Starting in 1919, prominent Hollywood attorney Loyd Wright developed a unique family compound bordering Idyllwild's core, with lodge and cabins for three branches of the family, caretaker, cook, and guests, plus facilities for swimming, tennis, handball, horses, parking, and storage. Daughter Jane Wright is on the badminton court. Marilyn Monroe and Joe DiMaggio secretly honeymooned here. The structures were recently demolished to accommodate a planned community recreation center.

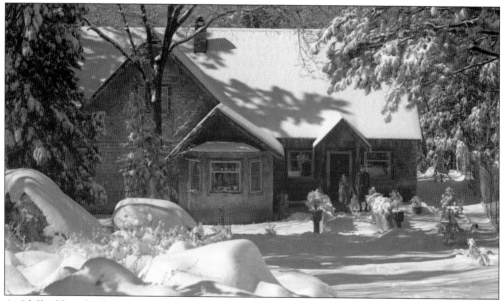

As Idyllwild evolved into a year-round settlement, most summer vacation cabins became too small for normal everyday living and could not be kept warm enough for comfort during the mountain winters. Larger and more substantial dwellings began to appear, and the Wheeler residence was an early example. (Wendelken Collection, IAHS.)

Despite a surge of new construction in the 1920s on lots sold by Emerson's Idyllwild, Inc., in Idyllwild and lower Strawberry Valley, and by Strong and Dickinson's Idyllwild Mountain Park Company in Fern Valley, much of the developed landscape still felt pristine. Only the unnatural circles and rows of stones, freshly cut pine and cedar stumps, and strolling couple suggest that this was a residential neighborhood. (Field Collection, IAHS.)

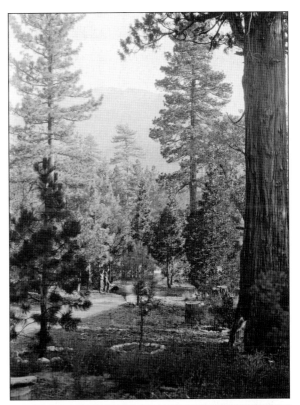

Although it may seem an odd designation today, Fern Valley got its name honestly. When Strong and Dickinson sold the center of Idyllwild to Claudius Emerson's group, they retained the upper portion of Strawberry Valley. In 1923, they began capitalizing on the outward radiation of settlement during the boom by developing their holding. Civilization thus invaded, and ultimately decimated, the great sea of ferns above Idyllwild.

Despite the village's quiet isolation, the question "What's there to do here?" seemed not to occur to children of an earlier era. Like those today who are fortunate enough to receive a fair dose of contact with nature, they amused themselves. Here from left to right, Billy Butts, Judy Butts, and their friend Pat Johns devised their own imaginative world on the Butts patio.

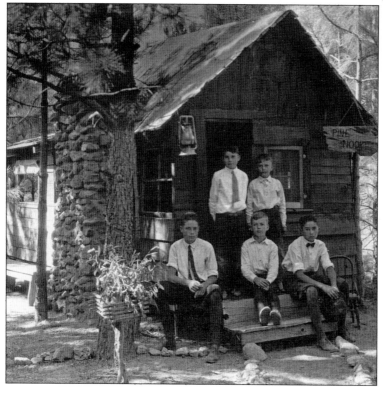

Some Idyllwild youngsters had larger ambitions. In 1926–1927, the Emerson brothers, whose parents ran the Idyllwild Inn, and the Bosworths, whose father ran the Idyllwild Store, devoted two full summers to building this fine little cabin, Pine Nook, entirely by themselves. Its "dedication portrait" includes, from left to right, (first row) Clarence Bosworth (lead builder), John Emerson, and Chuck Bosworth; (second row) John Bosworth and Lee Emerson.

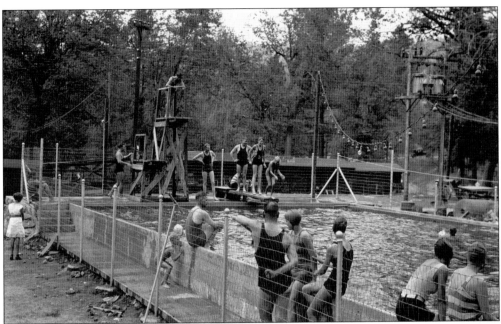

Communal recreation helped draw the young village together during the 1920s. The Idyllwild Inn's immensely popular Idyllwild Plunge (above) was located behind the general store and electrical plant at the main intersection of Circle Drive with the Hemet-Banning road, where today's Center of Idyllwild (the "Fort") stands. The public swimming tradition continued with successively remodeled pools at this location until 1966, when the last one was removed to make way for Welch's Carriage Inn. The first bowling alleys (below), which shared a building with a barbershop and "ladies' shampoo" salon, offered another form of amusement. The pool cues, however, remind us that, at least in some minds, bowling as a pastime once had less wholesome associations. (Above, Field Collection, IAHS; below, Wendelken Collection, IAHS.)

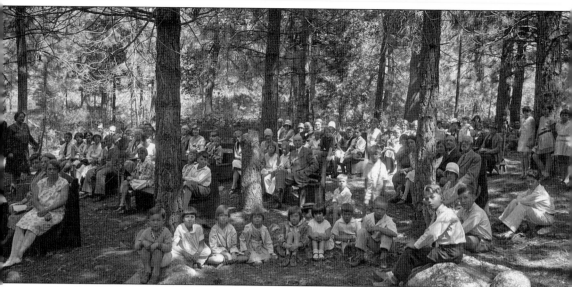

Claudius Emerson had firm ideas about what went into a wholesome social environment. To encourage a proper community in Idyllwild, he devised and oversaw a multifaceted development program. He gave away land for summer camps but almost entirely to groups he considered desirable, such as scouting and religious organizations. He expanded outdoor recreation facilities. He refused to serve alcohol at the inn and opposed its availability throughout the village. And during the years before local churches became established, his Idyllwild Inn met the needs of guests and residents alike by sponsoring weekly worship services during the summer. Attendance could be substantial, as this overflow crowd demonstrated. An appealing setting may have been an added attraction; at the least, it offered diversion for youngsters coerced into attendance on warm summer mornings, when other competing pursuits beckoned. (Field Collection, IAHS.)

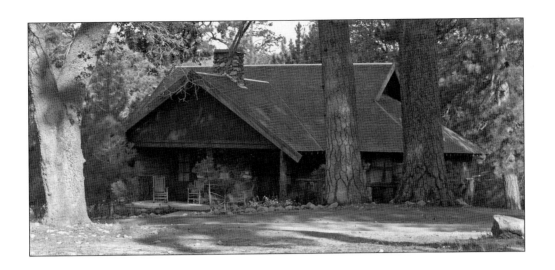

In the early 1920s, Presbyterians opened an outpost in Idyllwild, supplying temporary ministers for summer church services. According to old-timers, their first cleric lived with his family in a tent at the county park campground. Emerson's village proved fertile ground for a more established presence, so in 1925, the budding Community Presbyterian Church built a manse (above) beside a strikingly primitive Circle Drive. As the village grew, the Community Church was joined by Queen of Angels Catholic Church (below) on what is now North Circle Drive. By 1945, the latter had grown from modest, cabin-like quarters to the present, more expansive structure. (Above, Field Collection, IAHS; below, Wendelken Collection, IAHS.)

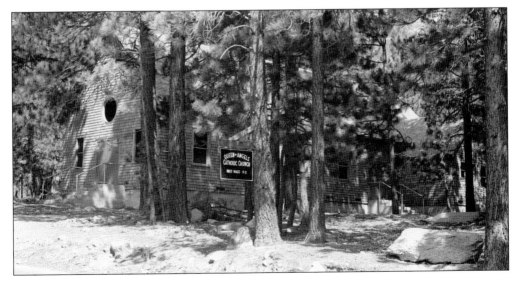

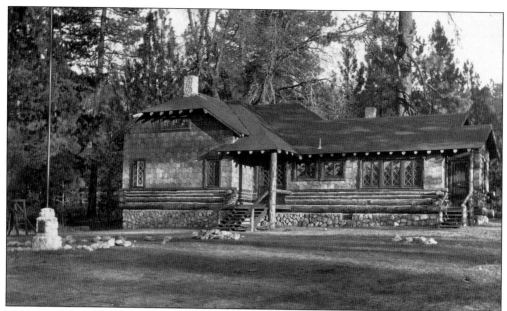

The old Idyllwild School (above) was the village's second, the first having been an emergency accommodation in a cabin. This school was built on the site where the Keen House once welcomed lodgers at the dawn of the 20th century. Playground facilities were minimal, but the great outdoors was close at hand. Serving Idyllwild's children from the late 1920s, it was outmoded and outgrown by 1948, when today's school began to replace it. The comparatively small size of the student body in their 1942–1943 portrait (below) reflected the severe drop in Idyllwild's population as a result of Depression and war. The teacher at left was Martha Woods, the one at right unidentified. (Above, Field Collection, IAHS; below, Wendelken Collection, IAHS.)

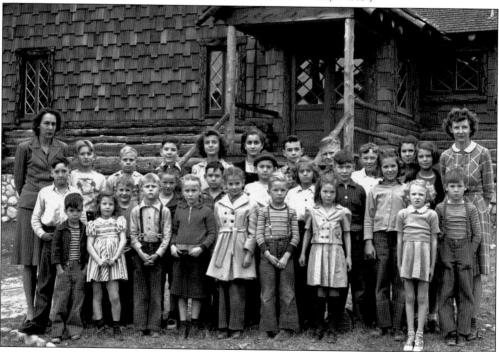

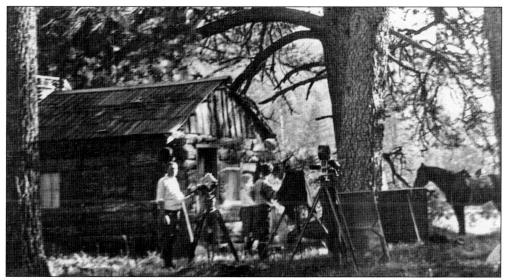

Cecil B. DeMille discovered the Keen Camp area (today's Mountain Center) in 1914, finding it ideal for shooting such films as *The Girl of the Golden West* and a series of Northwest Mountie features. Here Mary Pickford waits between two cameramen by a cabin that may date to the 1890s on the Lou Crane ranch, which the Keens bought in 1905 in order to create Keen Camp.

As Hollywood returned again and again to the San Jacintos, movie-making spread from Keen Camp down to Garner Valley and up into Strawberry Valley. Just getting to a chosen filming site could be a challenge for cast and crew alike. Nevertheless, over 70 feature films have been made in the Idyllwild area since 1914. (Local History Collection, Hemet Public Library.)

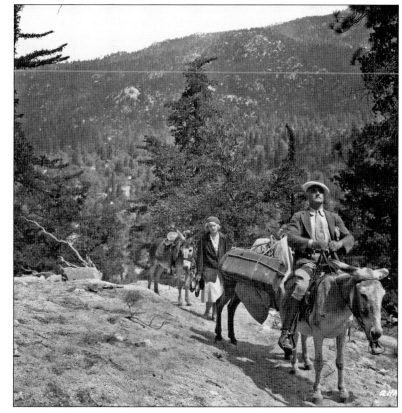

In 1952, an MGM film crew was at work on the shore of Lake Hemet, filming *Desperate Search*. Filming in the mountains could pose unique logistical challenges. The seaplane flown in for this film landed on the water without incident. But the lake's surface, at an altitude of 4,350 feet, proved too high and small to allow takeoff.

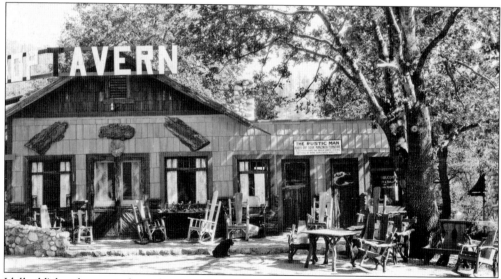

Idyllwild's best known industry between the 1930s and 1950s was craftsman furniture. The pioneers in the 1920s were Ellis Griest working with pine and Hal Holcomb with manzanita. Holcomb operated as "The Rustic Man"; his shop was located at the Rustic Tavern (today's Silver Pines Lodge). Griest would become known for his Woodland Craft line, sold at a shop of the same name in the village's core.

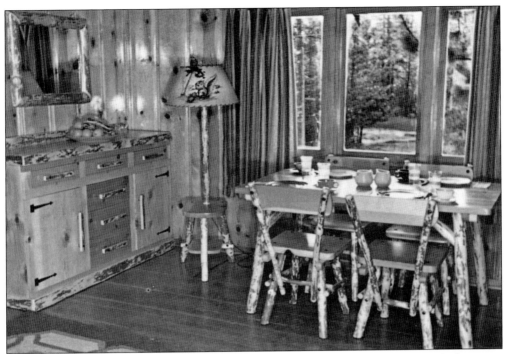

Between 1937 and 1952, C. Selden Belden set the industry standard with his "Pinecraft" furniture, samples of which are seen here in the Belden family home in Pine Cove. Pieces bearing Belden's trademark now command premium prices (barring strokes of good luck at garage sales). After Belden's death in 1952, his widow, Coral, and son, Ted, continued the business until 1960. (Lori Belden-Pope.)

Selden Belden's secret, in addition to exquisite workmanship, lay in careful selection of local pine poles and painstakingly careful ageing of the wood, turning each stored pole weekly to prevent warping. Here he is inspecting a short section of pole at his shop and showroom, which later became a restaurant, most recently housing the Idyllwild Café.

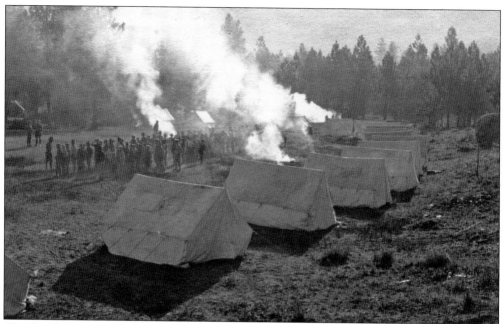

Claudius Emerson's first land grant went to the Riverside County Boy Scouts in 1921, launching what would become the Idyllwild area's largest and most permanent industry, the operation of summer camps. The property was named Camp Emerson in his honor. This photograph, taken that same year, shows Scouts assembling by their tents amid campfire smoke on a chilly morning during the camp's inaugural season.

Not widely known is the fact that for two decades Camp Emerson also served Riverside Girl Scouts, until the Azalea Trails camp was built for them in Dark Canyon in 1944. Here a collection of campers in the late 1920s gathers to be photographed around a familiar painted boulder at Camp Emerson. (Field Collection, IAHS.)

Another of Emerson's major land grants went in 1924 to a group of Christian businessmen, the Southern California Religious Education Council, for a training camp called Idyllwild Pines, which opened in 1928. Now operating year-round, it has become Idyllwild's largest organized camp. This photograph captured the new camp's gateway still under construction on what is now Highway 243 near the Strawberry Creek bridge. (Field Collection, IAHS.)

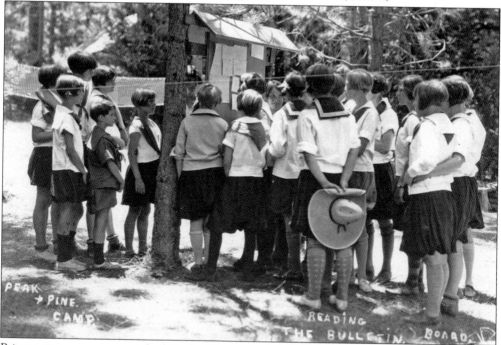

Private entrepreneurs enriched Idyllwild's array of summer camps with their own specialized offerings. The Peak and Pine Camp for girls, located on the site of today's Rainbow Inn on South Circle Drive, was created and run by Harriet Snyder from 1923 to 1962. Here campers cluster around the bulletin board to check out news and daily activities.

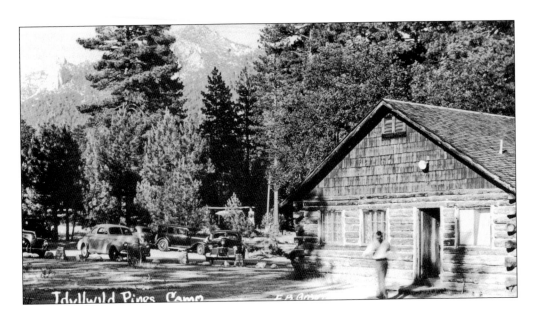

In addition to public campgrounds like the state and county parks, more than 20 privately organized camps have existed in the San Jacintos since 1920, the majority of them still operating. Their facilities were typically modest, like the Idyllwild Pines administration building (above). With its magnificent view of Lily Rock and Tahquitz Peak, this log structure is familiar to many from another widely distributed E. B. Gray postcard bearing the phrase "where memory fondly loves to stray." When first built, its interior (below) was spare but welcoming, with its river rock fireplace and similarly constructed Ketchum Memorial Fountain. (Below, Field Collection, IAHS.)

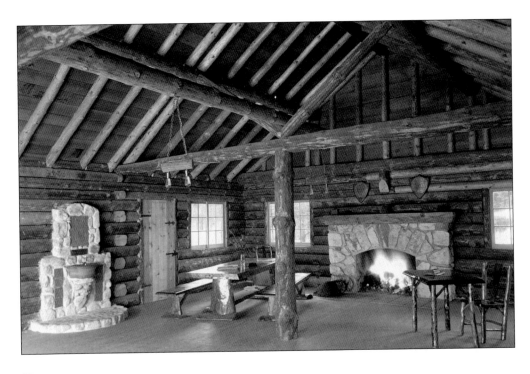

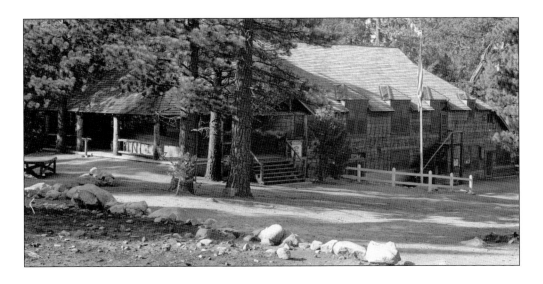

Unusual among Idyllwild camps, Tahquitz Pines Conference Grounds featured a central administration building (above) large enough to accommodate a spacious auditorium upstairs and kitchen and dining hall downstairs, plus meeting rooms and offices. The Los Angeles County Christian Endeavor Union bought this Fern Valley property from Strong and Dickinson's Idyllwild Mountain Park Company in 1929 and two years later began running summer conferences for Christian Endeavor groups from throughout the state. Campers from the 1940s and 1950s share fond memories of the camp store (below), a favorite hangout between formal sessions and source for everything from postcards to jawbreakers. (What it apparently did not facilitate was interaction between the sexes.) Tahquitz Pines is now a training facility owned by Wycliffe Associates, a highly regarded linguistics research, Bible translation, and missionary organization. (Above, Wendelken Collection, IAHS.)

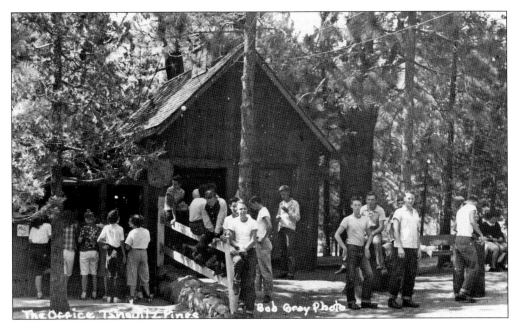

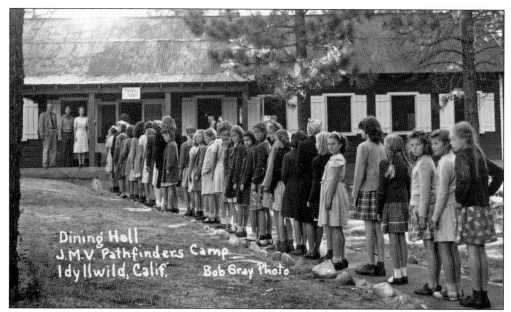

Even when they involved waiting lines, meals were welcome events for summer campers with appetites recharged by outdoor living. These girls in the 1940s were standing outside the "Dining Cabin" of Pathfinder Camp in Garner Valley. The camp continues to operate, now primarily serving Boys and Girls Clubs of the Palm Springs area.

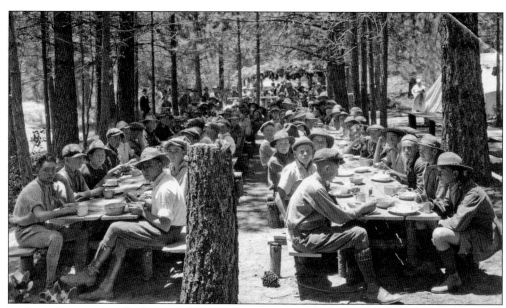

In Camp Emerson's early days, meals were served on rough-hewn tables and benches in a shady pine pavilion carved out of the forest. This lunchtime portrait captured a variety of 1920s uniforms. Now the oldest Scout camp west of the Mississippi, Camp Emerson draws Scouts from the entire Inland Empire to its original location on Strawberry Creek, just off Tollgate Road. (William Cooper.)

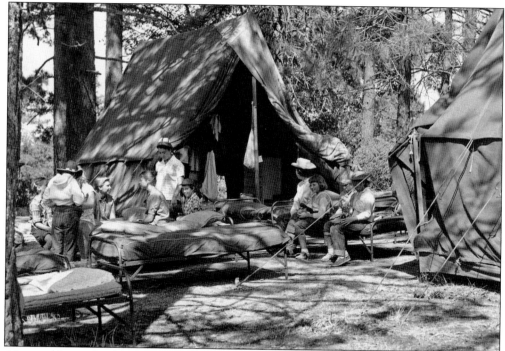

Along with meals, sleep was an important camp commodity, though often undervalued by campers. At summer camps operated by the private Desert Sun School at its Saunders Meadow campus (now Astrocamp), sleeping accommodations were primitive, offering a choice of cots in tents or out in the open air.

After the 1943 wildfire that destroyed Tahquitz Lodge and sounded the death knell for Keen Camp (see chapter five), the lodge site was put on the market. The Pasadena YWCA bought and renamed it Tahquitz Meadows in 1944. A new camp soon opened here, with sleeping accommodations in the form of spacious tent cabins. The wash day scene suggests that water and other utilities were included or located close by.

The camp that relied most heavily on canvas as a trademark was Idyllwild Pines. Its sleeping quarters were scattered in a "tent city" that sprawled far and wide amid the pine trees. Accommodations varied from simple tents erected temporarily to tent cabins (pictured here) to permanent cabins with canvas window flaps.

Tahquitz Pines campers were housed in more substantial structures. Men and boys bunked in large military-surplus Quonset huts shared by two dozen or so campers, envying women and girls for the more intimate dormitory cabins seen here. Quasi-military housekeeping standards, with a daily neatness competition among the dormitories, were an irritant, but afternoons packed with outdoor recreation did contribute to sound sleep.

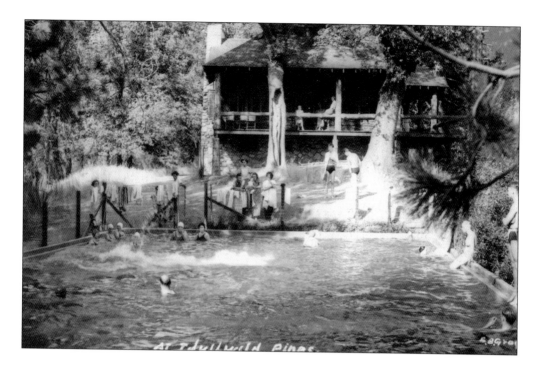

Most Idyllwild-area camps have featured a swimming pool, for both coping with hot summer afternoons and (one suspects) working off excess adolescent energy. The Idyllwild Pines pool (above), built into a hillside amid the pines below Emerson Hall, appeared primitive, but at least it needed no onerous rule against running on decks. In contrast, the pool with perhaps the most picturesque setting, a panoramic view of the surrounding forested mountainsides, sat on the sunny plain of Tahquitz Meadows (below), near Mountain Center. Originally created for the Tahquitz Lodge and a survivor of the 1943 fire that razed that resort, this pool would serve YWCA girls until the camp closed in 1980.

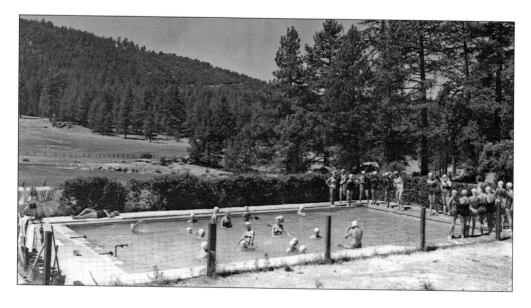

During World War II, the Riverside Girl Scout Council built its Azalea Trails Camp on a shelf above the North Fork of the San Jacinto River, high up in Dark Canyon. As befitted the most remotely located camp in these mountains, its water feature was a natural pool in the nearby creek. This group of Scouts gathers cautiously around it.

Mountain camps offered several kinds of active recreation along with swimming. Softball, basketball, and tennis were common, but volleyball was especially popular, and courts to accommodate it were everywhere. A grassy clearing at the Desert Sun School offered an especially pleasing site. In this photograph, volleyball players compete on the court while rays of late afternoon sunshine illuminate a distant cloud of dust raised by passing horseback riders.

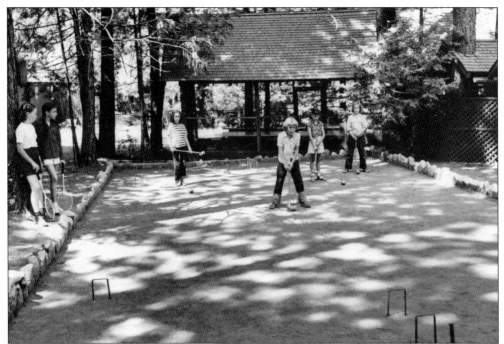

Peak and Pine Camp offered more refined forms of recreation. For example, capitalizing on the early-century popularity of croquet, it had a permanent court (above), shown in 1949 as Janet Dalton of San Marino lines up a shot, watched by resting badminton players. Just beyond the court was the open-air dining area and kitchen building. (Summer campers were liable to find snapshots from one year's session showing up later on postcards, and this scene indeed appeared on a card Dalton mailed home in 1950.) Peak and Pine girls, like the 1948 trio below, tended to come from a stratum of Southern California society likely to engage in horse shows. The camp maintained stables and extensive practice rings along the Control Road (now Tollgate Road) near its junction with today's Highway 243.

Horseshoes, often considered an older men's game, reached a younger generation at Desert Sun's camp. This private school, the lifetime project of Richard and Edith Elliott, moved from Coachella Valley to Saunders Meadow in 1946 after maintaining an Idyllwild outpost for several years. It occupied the former Mount San Jacinto Golf Club, which in 1928 had been Strong and Dickinson's short-lived answer to Emerson's well-established Idyllwild Golf Club.

Boy Scouts, of course, had their own specialized varieties of outdoor activity, and Camp Emerson provided an excellent base for engaging in them. In this 1920s photograph, while Tahquitz Peak towers above Domenigoni Flat, a small troop of Scouts carries out a field exercise near the camp. (Field Collection, IAHS.)

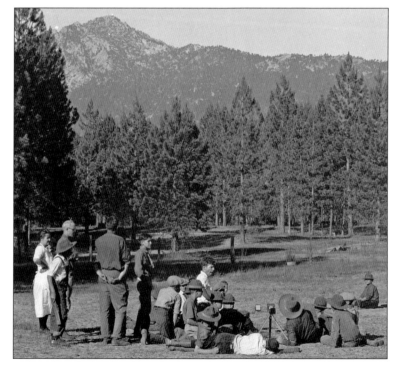

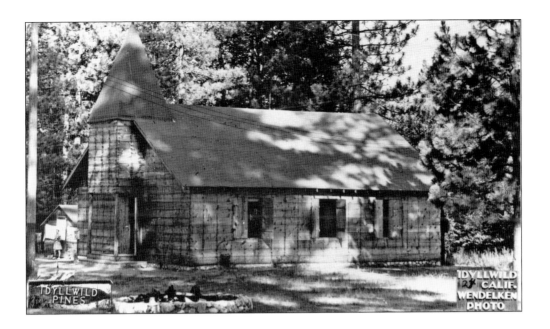

Despite their popular recreational programs, religious camps were created for inspirational purposes, to offer an encounter that differed significantly from church routines at home, lending concrete substance to the phrase "mountain-top experience." For many among the generations who have camped at Idyllwild Pines, its simple chapel (above) remains a spot dear to the heart. Another fixture of the religious campgrounds was an outdoor amphitheater for gatherings, usually at night, of a more introspective character than indoor auditoriums could encourage. With or without a campfire, the outdoor setting's closeness to nature reinforced a meeting's spiritual overtones, although it also encouraged certain unintended pursuits typical of adolescents under cover of darkness. "The Bowl" at Idyllwild Pines (below) was well situated for sun-drenched daytime services as well. (Above, Wendelken Collection, IAHS.)

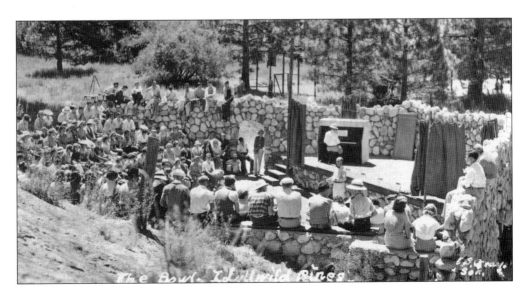

Programs for adolescents succeed or fail with the quality of teachers and counselors a camp's management attracts. Some relied on paid staff, but camps catering to a wide variety of groups more commonly relied on volunteers for these crucial ingredients. This photograph caught a typical group, the faculty of the 1935 California Baptist Young Peoples Conference, posing briefly during a break from their usual responsibilities.

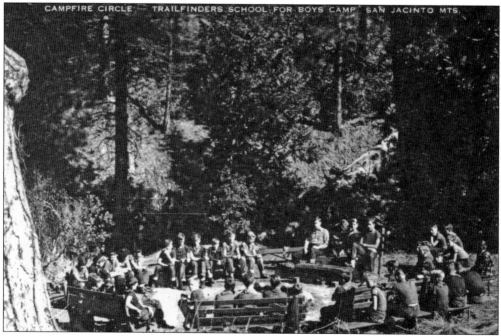

In 1941, outdoor educator and early wilderness activist Harry James acquired 30 acres in Hall Canyon, site of both the San Jacintos' earliest sawmill and future Lake Fulmor. For 15 years, he ran his Trailfinders camp for boys, inspiring many to mature through hiking, camping, and mountain climbing. He willed the property to the University of California for an ecological research and education center, the James Reserve.

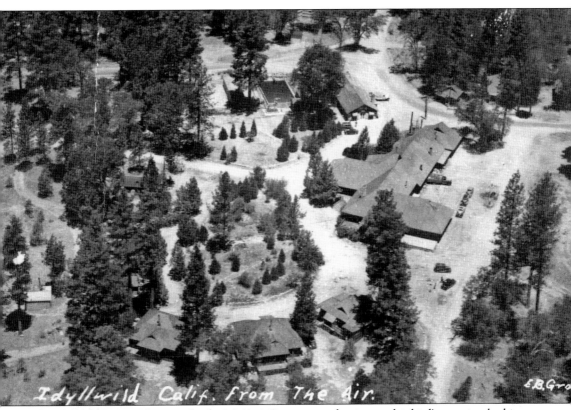

Idyllwild Calif. From The Air. E.B.Gra

The Idyllwild Inn, on the site of today's Jo'An's Restaurant, dominates this bird's-eye view looking northwest across Idyllwild's core in the early 1930s. The swimming pool appears near the top of the photograph, bordering the village's main "highway." The Idyllwild Store stood between the inn and the pool, near the triangular, oak-shaded intersection of the highway with curving Circle Drive. Just across Circle Drive from both store and inn was the log cabin housing Emerson's real estate office. Ridgeview Drive, leading away from the inn to the left, and Park Lane, between inn and store, were established thoroughfares, but future Village Center Drive was barely a trace in the dust to the right of the inn. Buildings in the foreground housed businesses and homes; the inn's cottages were beyond the picture's right border. A small building visible among the trees to the left of the inn on Ridgeview was probably E. B. Gray's souvenir and photography shop, previously occupied by Avery Field's Idyllwild photography studio.

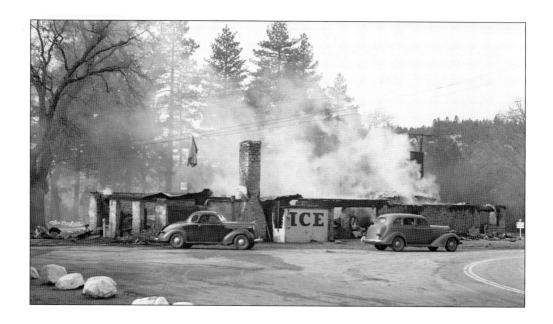

Through the 1920s and 1930s, the Idyllwild Store, which also housed the post office, stood facing the Idyllwild Inn on the site of today's Center of Idyllwild (the "Fort"). Then in 1941 (above), it suddenly shared the fate of such landmarks as the Idyllwild Sanatorium/Strawberry Valley Hotel, Tahquitz Lodge at Keen Camp, the Idyllwild Inn, and Sportland (which would soon occupy the same site), succumbing to a disastrous fire. Undaunted following the fire, developer Jerry Johnson immediately built a new grocery market (below), and newly unemployed storekeeper Elmer Horsley signed on to manage it together with Clarence Bosworth. Thus was born today's Village Market. (Above and below, Wendelken Collection, IAHS.)

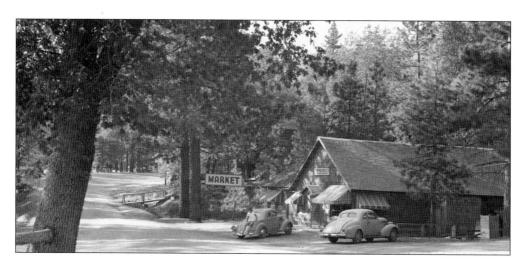

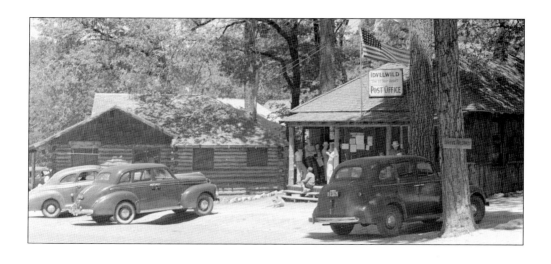

Following the 1941 fire that destroyed its quarters in the Idyllwild Store, the post office (above) moved across Circle Drive next door to the venerable log cabin. Lacking home mail delivery, villagers have always used their daily post office visit for social interaction, as is evident in this 1940s scene. Also in the 1940s, more commercial buildings joined the log cabin on Circle Drive (below, at far right). From left to right, they were the Idyllwild Garage, San Jacinto Mountain Lumber Company, Ellis Griest's Woodland Craft shop, the Gray family's new souvenir and photography shop, and a pharmacy and barbershop. The garage and lumber yard remain unchanged in function, but the others are now, from left to right, the Village Lane mini-mall, Faux Ever After, and the Red Kettle restaurant. (Both, Wendelken Collection, IAHS.)

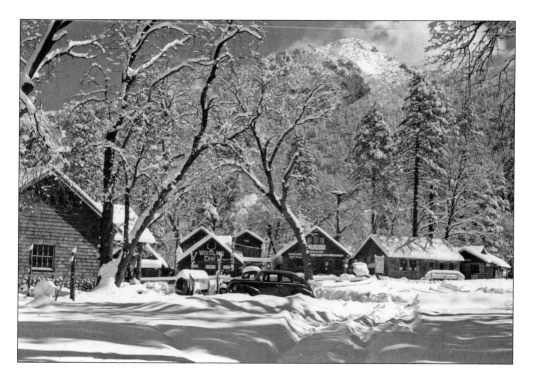

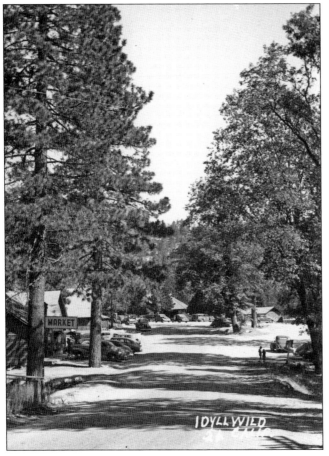

During World War II, the federal government engaged local citizens to scan the sky for enemy aircraft from observation posts set up at strategic points. Here Sandra Wendelken visits the post at "Bluebird Hill Curve," where the highway from Hemet rounds a sharp bend to enter Idyllwild (above). While wartime travel restrictions starved Idyllwild's economy, it was kept on life support by troops on day passes from March Air Field, Gen. George Patton's huge Desert Training Center, and other nearby bases. Still, as the war ground on through 1944, the occasional motorist entering Idyllwild from Pine Cove and Banning (left) was confronted with an increasingly sleepy mountain village. In the distance is the Idyllwild Inn and to its right the community plunge. (Above, Wendelken Collection, IAHS.)

Five

REFUGE
BEYOND THE VILLAGE

The unique appeal of the San Jacinto Mountains stems in part from their rugged topography, dense forest, and clear air. Still more important is a pervasive sense of isolation from a Southern California that over the past half-century has devolved into a chaotic jumble of smog-shrouded freeways, cramped housing tracts, and repetitive commercial hubs.

To some, the desirable characteristics of mountain wilderness are unacceptably compromised by a tourist center, even one as modest as Idyllwild. Feeling no need for shopping, dining, or packaged entertainment, for which they need not leave suburbia, they are attracted to the prospect of having unmediated access to nature literally at their doorstep. Since the 1860s, such adventurers have been attracted to uninhabited valleys, ridges, meadows, and creeks, usually in the back country, sometimes at more accessible locations, all of them away from Strawberry Valley.

A sprinkling of isolated private tracts amid public land has survived to this day. Most derive from railroad land sold to loggers before creation of the forest reserve, but a few were agricultural homesteads under the Forest Homestead Act of 1906 or summer home sites leased from the forest service after 1915. This chapter highlights two examples of settlements away from Idyllwild. Ironically, both were initially intended to compete with Idyllwild as commercial ventures.

Keen Camp succeeded commercially for two decades, but without a surrounding village, it retained a feeling of remoteness. Pinewood failed commercially at the outset and instead became a summer retreat for a few families, then slowly evolved into a remote, still primitive community of three dozen cabins, some now in their fifth generation of family occupants.

Any neighbors at all were too many for a few hardy souls, who simply squatted on the public domain in the days before rangers patrolled the high country. Some cattlemen and trappers who returned repeatedly or made extended stays built crude log cabins in the high country. The most elaborate back-country residence was built by journalist George Law high in Tahquitz Valley on Willow Creek.

Even before construction of the Control Road in 1909, a primitive food and lodging facility known as Summit Camp existed at the far end of the road from Hemet. After George Hannahs sold 800 acres to a Long Beach group in 1924, scattered cabins appeared, and by the 1940s, the tiny settlement of Pine Cove clustered loosely around a gas station, market, branch Idyllwild post office, and the popular Lookout Café (above). Substantial development awaited completion of the new Banning-Idyllwild highway in 1950, and C. A. Hoffman's real estate agency (below) was ready to capitalize on the exposure. Unlike Fern Valley, which blends continuously into Idyllwild, Pine Cove residents have long distinguished their quiet community from the commercial hub below on the floor of Strawberry Valley. (Above, Wendelken Collection, IAHS.)

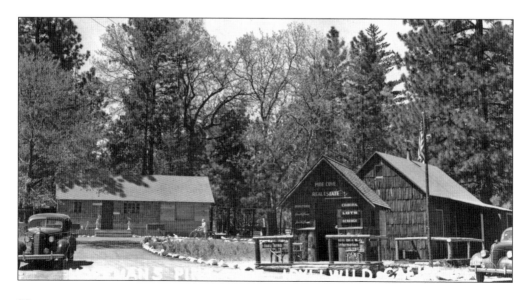

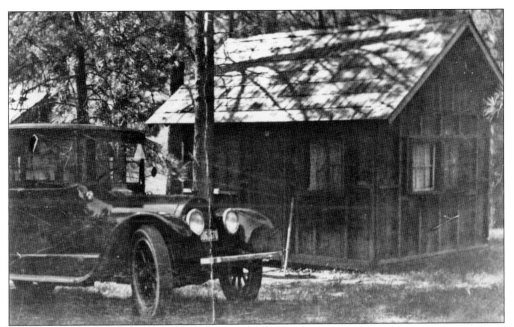

Retreating from the Idyllwild Inn's overwhelming popularity, John and Mary Keen in 1905 sold their Strawberry Valley land to Frank Strong and George Dickinson. They moved the Keen House down to ranch property they had bought on the old Mayberry road to Lake Hemet, near the site of today's Mountain Center. Here they added a lodge and cabins (above), calling the new resort Keen Camp. The settlement merited its own post office by 1909. In 1911, the Keens retired, selling their property to Anita and Percy Walker, who expanded the resort, catering primarily to Hemet and San Jacinto residents as an escape from the summer heat. By 1915, a twice-daily motor stage from Hemet and San Jacinto (below) stopped at the Keen Camp store.

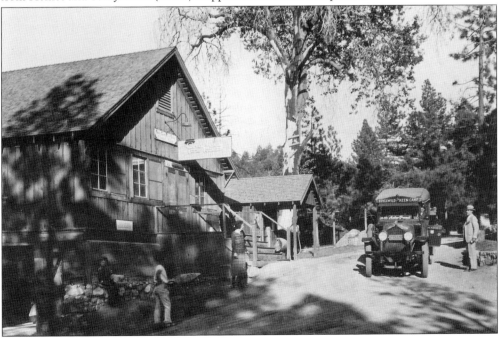

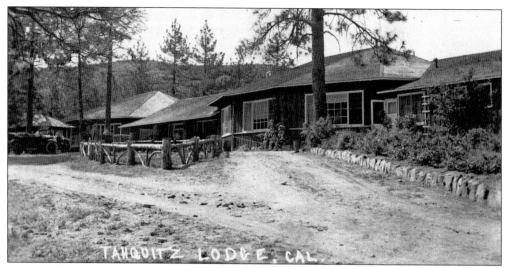

TAHQUITZ LODGE, CAL.

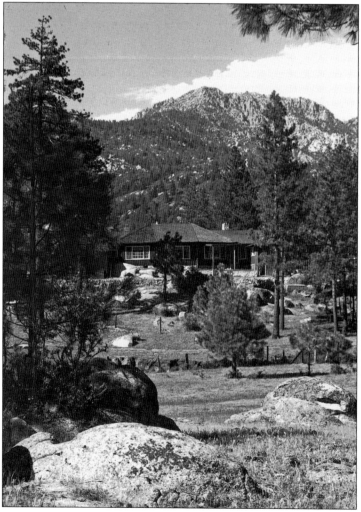

Percy Walker drowned accidentally in Lake Hemet in 1912, and the main lodge at Keen Camp burned down in 1915. But Anita Walker rebounded from both tragedies to take charge, marry Robert Elliott, and rebuild a more elegant lodge. The sprawling, ranch-style resort (above) saw its popularity soar with visitors from San Bernardino, Riverside, and other inland valley towns who appreciated the quiet, spacious location. (Idyllwild seemed to appeal more to city folks from the coastal counties.) Picturesquely situated among scattered pines, with a clear view of Tahquitz Peak (left), in 1919, the Keen Camp resort was renamed Tahquitz Lodge, sometimes mistakenly rendered "Tauquitz." (Left, Field Collection, IAHS.)

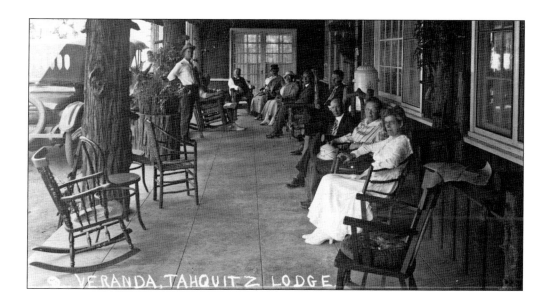

Spacious rooms and first-rate facilities at Tahquitz Lodge were a pleasant surprise in such an out-of-the-way setting, well off the main road between Hemet and Idyllwild. Guests loved to gather on the long veranda of the main lodge (above) to chat and enjoy the mountain air. Guest rooms (below) were elegantly equipped and seasonally decorated, as in this Christmastime photograph. Then in 1924, new owners turned the resort into a private club, which failed financially. By the time the Walker-Elliott family regained control in 1930, competing with the Idyllwild Inn had become an impossible challenge, and Tahquitz Lodge never regained its footing. (Above, Laura Swift collection, Hemet Public Library.)

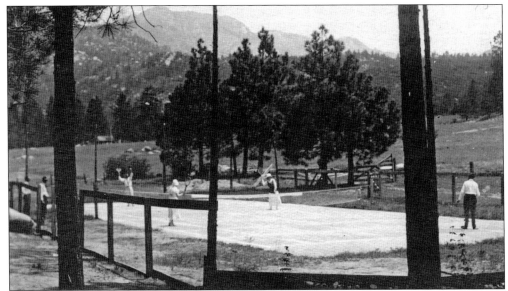

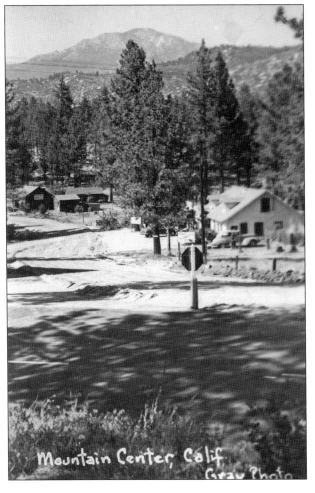

Anita Walker Elliott's transformation of Keen Camp to Tahquitz Lodge between 1916 and 1919 included adding a tennis court (above), along with a swimming pool, dining facilities for 200, and reputedly the largest ballroom in Riverside County. The court and pool would survive the resort's destruction by a 1943 fire to become key features of the subsequent Tahquitz Meadows YWCA camp. But the fire cost the Keen Camp store and post office much of their clientele. Relocated to the junction of the Idyllwild and Pines to Palms Highways (left) and renamed Mountain Center in 1945, they remained, together with Malcolm Taylor's popular Mountain Center Lodge cabins and café, the commercial focus of a scattered upland settlement.

In 1905, newly transplanted West Virginia mountaineer C. Beverly Hughes rediscovered the abandoned Fuller's Mill site (see page 15) and began spending summers there. Banning neighbors sometimes visited him, like this group of unidentified 1908 picnickers posing before a large black oak just steps from the mill (behind Hughes's camera). The oak and remnants of the mill's foundation remain in place today. (Banning Library District.)

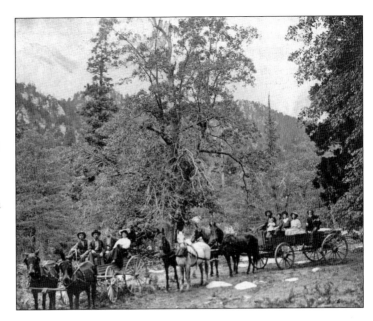

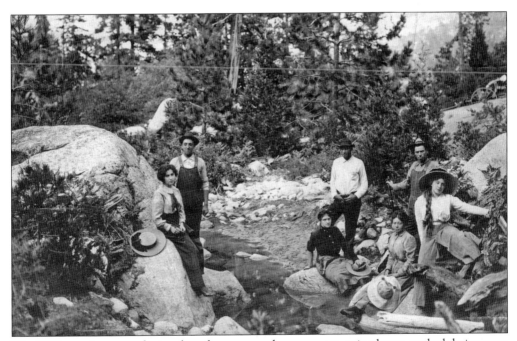

The 1910 camping party depicted on the cover, perhaps now returning home, parked their wagon and paused by Fuller Mill Creek. From left to right, Pearl Clark, Ivy Kolb, Clara Greene, Carl Sweeters, May Bailiff, Bert Bailiff, and Frances Kolb were lucky to find water still flowing at the end of August. "Mrs. Greene" (so identified in the week's *Banning Record*) evidently chaperoned these "youngsters."

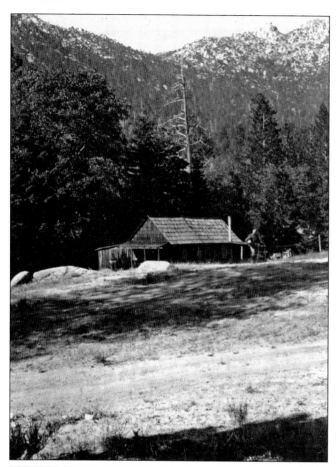

Between 1905 and 1912, homesteader Beverly Hughes settled into the one-room, 1878 foreman's cabin at Fuller's Mill, adding another room and kitchen at its rear. A 1927 photograph (left) shows a later fourth room at the left. Attorney Francis D. R. "Frank" Moote led a Los Angeles syndicate that bought the homestead in 1925 for a resort to be called Pinewood. But recession and scarce water scuttled the project, leaving the Moote family with a vacation retreat. Daily life took place in "Moote Camp," a nearby level spot shaded by oak and pine, leaving the cabin mainly for storage and sleep. At meals, Frank always presided at one end of the camp's dining table. This early-1940s breakfast party (below) included, from left to right, unidentified, Frank's daughter Dorothy Moote, unidentified, Frank Moote, and his wife, Mabel Moote. (Below, author.)

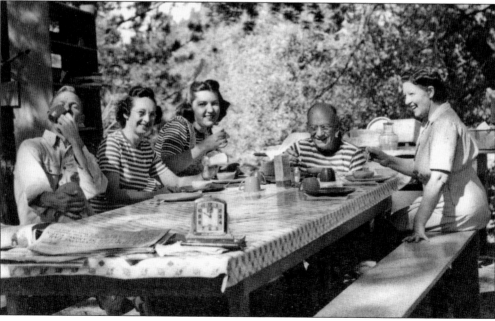

Wood remains Moote Camp's sole source of heat today, and in 1930, a huge stove was built of native granite to serve Pinewood cooks, here exemplified by a family friend, Anna McGuffin. The outdoor "kitchen" was well equipped with an adjacent work table, a standing faucet delivering fresh spring water, and a tall shelving unit nailed to a massive sugar pine to store dishes, utensils, and canned goods.

The Mootes often invited friends to their camp, treating them to the perennial camp delicacy, fresh ice cream. Here John Bush was recruited to operate a self-propelled freezer. (Actually, an additional strong arm was always required to turn the crank as the cream approached its frozen state.) An icebox in the cabin held block ice to be crushed for such occasions, meanwhile serving to preserve perishable foods. (Author.)

Pinewood's isolation and solitude fostered rest and reflection, and reading was a popular way to achieve both. Guests often slept on cots set up around the open fire circle at the heart of camp, where sawmill blacksmiths once had their forge. Frank Moote is silhouetted at far right against a portion of the hillside apple orchard Beverly Hughes had planted in 1910 to prove up his "agricultural" homestead.

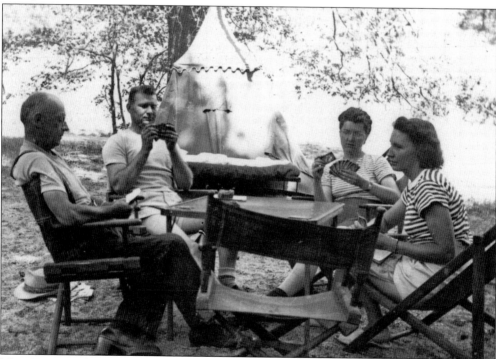

Many Pinewood hours were devoted to card games, with rook dominating the early years. Wartime addicts included, from left to right, Frank Moote, John Bush, Betty Bush, and Ann McGuffin. Later less puritanical generations broadened the menu, starting with the 1950s canasta craze and progressing to gin rummy, hearts, and oh hell. The canvas tent accommodated camp guests too timid to sleep out by the campfire. (Author.)

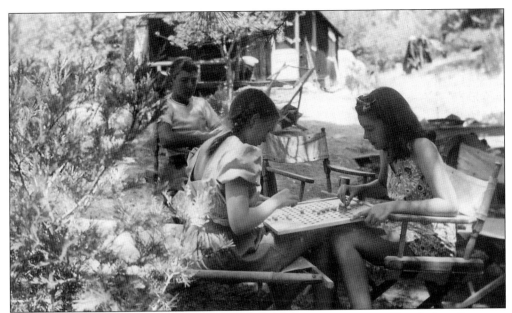

Board games became a growing preoccupation with passing generations. Here JoAnn Patterson (center) entertains friends in 1939 at her family's cabin, located across a deep gully from Moote Camp. (Her father, Earl, was Moote's law partner and the only Pinewood Syndicate member who did not default.) From dominos and Chinese checkers, the popular repertoire expanded in the 1950s to Monopoly, Parcheesi, Clue, and All-Star Baseball. (Caerleon Safford.)

Around 1917, surveyor Richard Sumner obtained acreage on a steep hillside bordering the Pinewood tract as payment for professional services and appropriated another old cabin from the sawmill era. The Sumner and Moote families and their descendants have been friends through five generations. In 1942, Sumner's grandchildren, Sherry and Dick Simpson, show off their well-furnished oak treehouse. (Sherry Hibbard.)

Though isolated in the forest miles from civilization, Pinewood was not totally divorced from high culture. In the summer of 1949, Donald Poundstone suffers through a daily practice session enforced by his mother, Kathleen Moote Poundstone, while Penny Smith, daughter of Margaret Moote Smith, provides an audience. Until transistors and batteries intruded, only a windup Victrola in the cabin supplied canned entertainment.

Ahead of its time, the Mootes' outhouse in the apple orchard above the old cabin was a distinctive duplex equipped with flush plumbing. On its interior walls, the Moote sisters expressed their propensity for bathroom humor, inspired by signs filched from the Hollywood Bowl ("No Parking During Bowl Events"). This 1930s photograph caught, from left to right, two unidentified friends, Kathleen Moote, and Dorothy Moote.

Pinewood vacations often featured trips to the Black Mountain fire lookout, followed by a stop at Farview Point on Fuller Ridge to gaze at San Gorgonio Peak at sunset. On the Fourth of July, fireworks rose from the dusk at Beaumont, Banning, and Cabazon in the pass below. Here the Simpson family—from left to right, Sherry, Evangeline, Dick, Bob, and Winchell—pose on the point around 1947.

In the decades around 1900, some loners sought complete solitude, away from traffic and even neighbors, by building simple log cabins in the valleys surrounding Idyllwild. The exact location of this choice example, illustrating domestication of the wilderness sufficient to support at least temporary residence, is unknown.

Some back-country cabins were accommodations to necessity. During the years around 1890, Frank Wellman grazed stock in Tahquitz Valley for several ranchers and is said to have built this cabin high on Willow Creek near its source in Wellman's Cienega. Energetic tourists were attracted to it in later years, but now only scattered logs remain. (San Jacinto Valley Museum.)

The ultimate in isolated refuges was George Law's cabin, near the confluence of Willow and Tahquitz Creeks at an elevation of 7,800 feet, more than seven trail miles from Idyllwild. An eccentric freelance writer for newspapers and magazines, Law built the structure with on-site materials (except for the glass door!) in 1915 and lived here with his wife, Lela, from May to October each year through 1925. (Wendelken Collection, IAHS.)

Six

RENAISSANCE
THE VILLAGE EVOLVES

During 1946, in response to developments in the outside world, Idyllwild turned a corner. Southern California's population had begun to boom again. Americans were eager to get back out of their houses to explore the country they had lately preserved from destruction. The consequences for "the Hill," as residents began to call Strawberry Valley, posed both threat and opportunity.

The forest service, still focused on growing and harvesting trees, felt intense pressure from the logging industry to raise limits on lumber production. Gov. Earl Warren quietly signed a bill authorizing the Palm Springs Tramway.

As a new highway from Banning neared completion, tourists began to flood the highways like never before. The ill-fated Idyllwild Inn was replaced; then its parent company was sold to a syndicate led by Idyllwild developer Jerry Johnson. This returned a prime hotel, water company, market, movie theater, rental cabins, and undeveloped acreage to local control. Ernest and Betty Maxwell settled in Idyllwild in 1946 and founded the *Idyllwild Town Crier*, while a group of University of Southern California professors bought land on Domenigoni Flat for a summer school in the arts.

Into this ferment stepped artist, teacher, and activist Ernie Maxwell as self-appointed prophet and cheerleader for both community development and environmental preservation. His newspaper became a vehicle to restore the spirit that once animated the village. He took aim at unplanned growth, logging, and industrial recreation projects like the tramway. Maxwell won some battles and lost some, but his legacy was a preservation ethic embedded in Idyllwild's character as an arts and outdoor recreation magnet.

After four years of planning, the Idyllwild School of Music and the Arts (ISOMATA) opened in 1950 and catalyzed an expansion of the Hill's embryonic resident arts community. With its high standards for training budding artists of all ages, the school would eventually join rock-climbing as one of Idyllwild's twin claims to global fame.

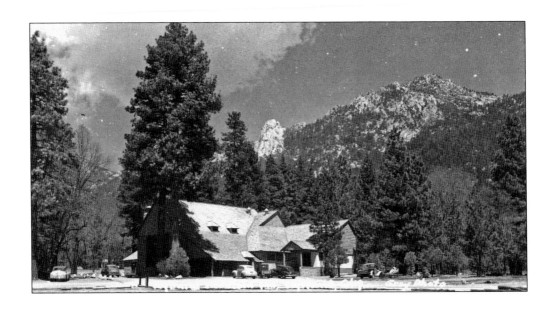

After clearing the rubble of the Idyllwild Inn, owner Paul Foster replaced it on the historic site of Camp Idylwilde and the Sanatorium, where the Village Centre shops stand today. The new Idyllwild Mountain Inn opened in 1946, an impressive sight backed by Lily Rock and Tahquitz Peak. But postwar tourist tastes were changing, and the synergy of the 1920s between lodge and village never returned. The unprofitable lodge's demolition in 1976 buried large-scale resorts on "the Hill," as locals had begun to refer to Strawberry Valley. Only the associated cabins would survive as the Idyllwild Inn Motel.

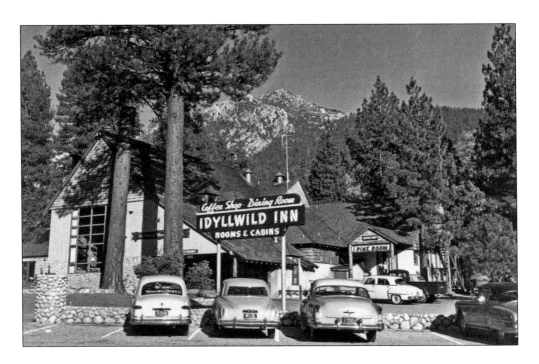

Developer Jerry Johnson pointed out the spot on Dutch Flat where Lily Creek would be dammed in 1946 and Strawberry Creek water pumped in to create Foster Lake as the Idyllwild Water Company's storage reservoir. Infrastructure thus began to fall into place for an Idyllwild renaissance that would see the population boom from 450 to 1,250 in 15 years.

During the postwar boom, periodic village festivals attempted both to energize community spirit and draw visitors to the Hill. One example was "Gold Rush Days," for which these ladies romanticized one aspect of California's origins. As Idyllwild's identity evolved toward the arts, community events followed, as evident in today's monthly gallery walks and annual jazz festival.

No project galvanized the dispirited community like construction of Town Hall (above). Prodded by the village's new newspaper, convinced of the need for a "community house" to bring citizens together, the entire business community shut down for one day in late November 1946 and turned out as a volunteer construction crew at the Cedar Street site to pour the foundation (below). In the foreground from left to right are Rollin Humber, Chuck Roberts, Vic Poates, Bill Hirsh, and Jim Patton. Town Hall opened the next summer. Now an Idyllwild fixture, its building and grounds remain in steady use today for civic meetings, entertainment and recreation, and educational programs.

Ernest Maxwell, over the objections of the local squirrel population, offered his skeptical wife, Betty, an acorn biscuit during a 1947 banquet (above). Ernie, a sculptor, painter, and nationally published cartoonist, and Betty, a Broadway actress, fell under Idyllwild's charm during a 1930s visit, bought a Fern Valley lot in 1944, and settled into their newly built house in 1946. Activists by disposition, they immediately founded the *Town Crier* newspaper, which they would publish until 1972. The weekly paper was still a home-based business in 1949 (right), assembled by, from left to right, Ernie, Betty, Marge Shideler, Hazel Cress, and Minnie Hodge.

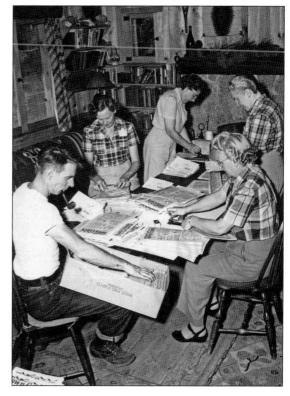

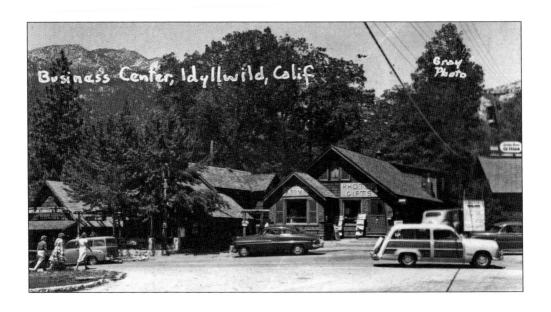

As Idyllwild recovered from Depression and wartime, an air of bustle returned to its core, fed by tourists and a growing resident population. Bob and Virginia Gray's photographic and souvenir shop was a landmark attraction (above), as was the former pharmacy-barbershop building next door (below). The latter had evolved into the Idyllwild Sundries Store, best known in the 1940s for its popular soda fountain. It soon would become the Red Kettle restaurant, the identity that lingers to the present. The presence of parked motorcycles perhaps foreshadowed the village's future attractiveness to touring bike clubs.

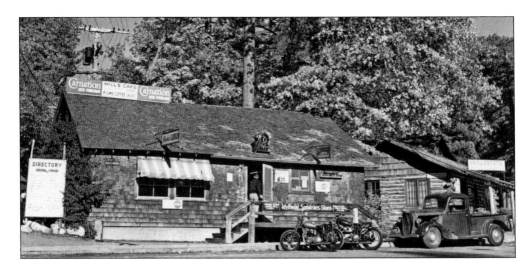

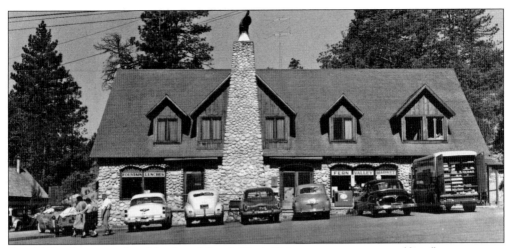

Fern Valley Corners, where North and South Circle Drives now meet, emerged briefly as a postwar commercial center competing with Idyllwild proper for the business of upper-valley residents, but it was located too close to the main village to distinguish itself. Its centerpiece, the massive Fern Valley Market (above), remains now as the Creekstone Inn.

A small, distinctive river-rock building, next door to the Fern Valley Market on Pine Crest Avenue, housed the *Town Crier* office for many years before becoming a bakery. The nature of businesses on three of the Fern Valley corners has varied, but the fourth has always served up food, with a 1946 hamburger stand evolving to today's Creek House restaurant.

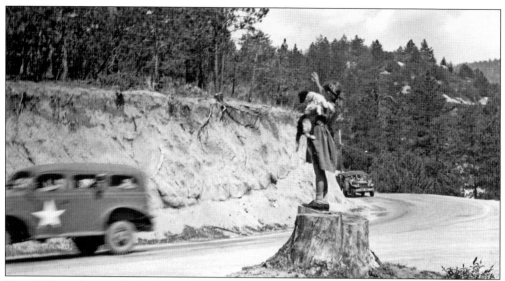

The Hill's tradition of welcoming military personnel was symbolized by Sandra Wendelken's personal greeting (above) to arriving World War II vehicles as they rounded the Bluebird Hill curve at Idyllwild's lower entrance. Armed services had been crucial to keeping the local economy alive through the early 1940s, supplying weekend visitors from General Patton's Desert Training Camp, March Field, and other nearby bases. During the winter of 1950–1951, Camp Pendleton sent marine contingents to the Hill for training maneuvers in Dark Canyon and the Fuller Mill Creek watershed prior to their deployment to Korea. One group (below) occupied itself between snowstorms by building a temporary log bridge across Lake Fulmor. (Above, Wendelken Collection, IAHS.)

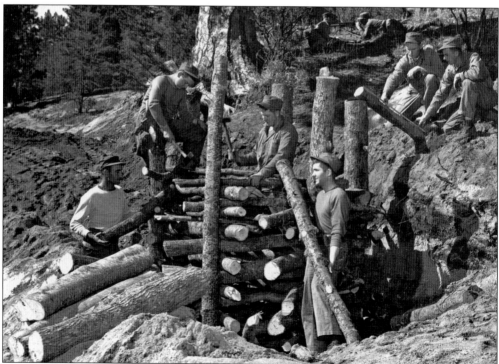

The most popular Hill celebration has always been the Fourth of July parade, a tradition that continues in the same informal, inclusive spirit. During the 1950s, students from the Idyllwild School of Music and the Arts (ISOMATA) joined in, contributing energy and talent to a pickup band that marched along with the townsfolk.

In creating ISOMATA, Dr. Max Krone (left), music dean at the University of Southern California, and his wife, Beatrice ("Bee"), wisely capitalized on the modest reservoir of artistic talent that had long resided on the Hill. For example, the Krones enlisted widely known local artist, photographer, and teacher Val Samuelson to illustrate Bee's next book of children's songs, as well as to teach at the school.

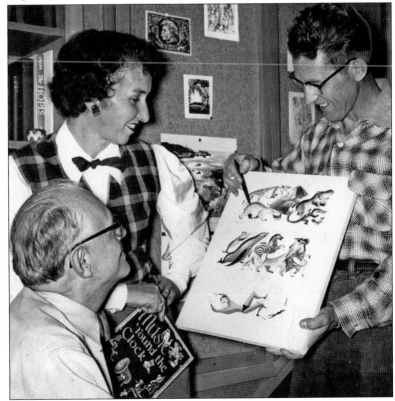

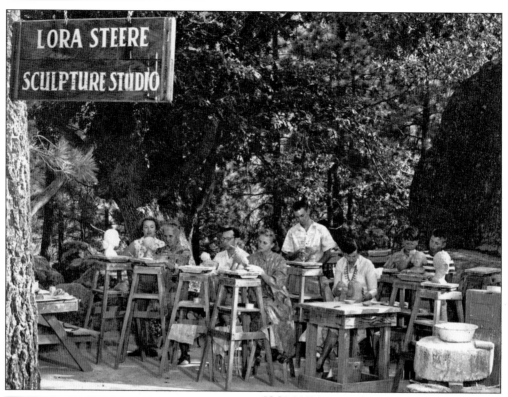

ISOMATA opened in summer 1950 with no facilities yet built, and classes were taught in the open air. On opening day, longtime Idyllwild sculptor Lora Steere (above, second from left) taught one of the first workshops. Thanks to her experience and guidance, sculpture has remained a central program in the Idyllwild Arts curriculum. (Krone Museum.)

The young ISOMATA summer school got a crucial boost in the 1950s from established musicians, artists, actors, and writers. Offstage, from left to right, composer Meredith Willson and choral conductor Roger Wagner confer with ISOMATA board member Ernie Maxwell. Wagner conducted workshops, while no one was more deeply involved with ISOMATA's early development than Willson, who actually wrote much of his beloved *The Music Man* at Idyllwild.

The eminence of ISOMATA's early faculty seemed to know no limits. At one unique moment during an outdoor photography workshop, an unidentified photographer snapped this picture of famed *Life* magazine photojournalist Alfred Eisenstadt himself capturing an image of the class's even more famous teacher, Ansel Adams. (Krone Museum.)

Renowned dancer Bella Lewitsky was another prominent figure lending prestige to ISOMATA's developing summer program in its early years, as she led annual workshops for young aspirants. Meanwhile, the school was gradually developing classrooms that were not yet indoors but at least offered some protection from summer thundershowers. (Krone Museum.)

121

Prominent New York printmaker, painter, and teacher Harry Sternberg instantly fell in love with the mountains and deserts of the West in 1957, quickly becoming one of ISOMATA's most beloved teachers. The reason is apparent in this 1959 view of him at work with aspiring high school painters, epitomizing the individual attention ISOMATA students received. (Krone Museum.)

ISOMATA's growing reputation attracted extraordinary student talent, a tradition that continues undiminished in today's Idyllwild Arts Academy, one of the nation's three boarding high schools in the arts. This section of the Idyllwild Youth Orchestra preparing to tour London and Wales included young Michael Tilson Thomas (first row, second from right), now a world-renowned orchestral conductor.

122

Folk music was a popular component of the ISOMATA summer program, and workshop instructors like Pete Seeger often entertained around the campfire. Here international balladeers and folk music scholars Josef Marais and his wife, Miranda, perform. The pair frequently taught in ISOMATA's early years, eventually building a home and settling on the Hill. (Krone Museum.)

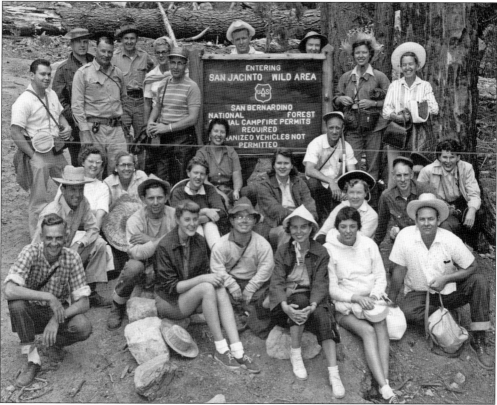

Through his roles on both the governing board and the staff of ISOMATA, Ernie Maxwell drew the school into an unusual collaboration with the Izaak Walton League (page 124), hosting an Idyllwild School of Conservation and Natural Science for Southern California teachers. These teachers were about to leave the Humber Park trailhead for Skunk Cabbage Meadow, where Maxwell (second row, second from right) led a wilderness workshop in the 1950s.

123

In 1948, Ernie Maxwell gathered local outdoorsmen into a new fish and game club, which quickly became a chapter of the Izaak Walton League with himself as perennial president. Among the first of their many projects for forest health and wilderness preservation was building check dams to improve fish habitat, demonstrated in Strawberry Creek in 1949 by Joe McGaugh (left), Mike Dunn (center), and Maxwell.

The most unusual project of the Idyllwild "Ikes," as Izaak Walton League members called themselves, was an attempt to reintroduce beaver into the San Jacinto Mountains. As Betty Maxwell (right) looked on, this specimen was released high in Tahquitz Valley in 1947. The project failed immediately in Alvin Meadow, just below Strawberry Valley, but imported beaver persisted for a time along Tahquitz Creek.

The Ikes wisely reached out to the next generation, sponsoring an Eagle Scout troop and cooperating with Idyllwild School on an Idyllwild Junior Rangers program. They showed educational films and enlisted children in projects like litter reduction. Their slogan, "America's Cleanest Forest," took on a life of its own and is still displayed around Idyllwild.

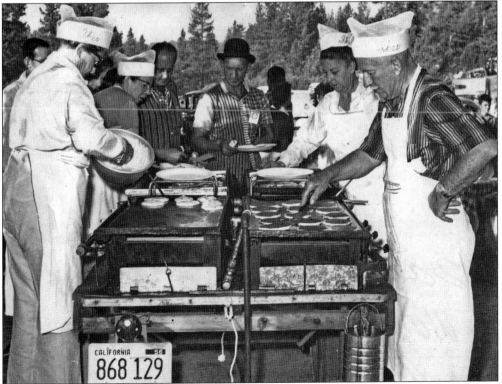

The Ikes raised project money with periodic "Woodsman Breakfasts" at the Riverside County Park campground. These popular events drew a wide following and kept the chapter's programs in the local consciousness. Chapter president Ernie Maxwell attracted broader attention and support through exerting leadership in the Izaak Walton League at the state level.

Among Ernie Maxwell's many talents, cartooning was his signature. His work had appeared in *Esquire* and the *New Yorker* magazines, but as an inveterate teacher, he readily shared it with children. This demonstration was on a stage in back of Town Hall.

Ernie Maxwell's silhouette at the desert overlook near Hidden Lake, where he was out on a wildlife survey, evokes the long shadow he cast over Idyllwild and the high San Jacintos through his 48 years on the Hill. Tangibly memorialized in the Ernie Maxwell Scenic Trail above the village, his spirit remains alive in the preservation ethic that pervades Idyllwild's character today.

Idyllwild Area Historical Society

IAHS was organized in 2001 as a 501(c)(3) charity by energetic Idyllwild residents concerned about losing buildings, artifacts, and memories of earlier times. Pursuing a mission both to preserve and to share San Jacinto mountain history, within 18 months, they found a perfect museum site and raised the money to buy it. Meanwhile, scores of local residents, past and present, were donating objects and images to an exponentially growing collection.

The museum, housed in a 1920s vacation cabin at 54470 North Circle Drive in central Idyllwild, opened its doors in October 2003. Displaying key aspects of mountain history in an uncluttered setting, it is open weekends throughout the year, with special summer and holiday hours. IAHS's early success attracted nearly 500 active members, and the museum now sees up to 5,000 visitors annually. A strictly volunteer organization, IAHS staffs its museum, office, archives, and special events with 50–75 full- and part-time residents.

More information about IAHS is available on its Web site, www.idyllwildhistory.org, which also contains an extensive, downloadable index to this volume.

ACROSS AMERICA, PEOPLE ARE DISCOVERING SOMETHING WONDERFUL. *THEIR HERITAGE.*

Arcadia Publishing is the leading local history publisher in the United States. With more than 4,000 titles in print and hundreds of new titles released every year, Arcadia has extensive specialized experience chronicling the history of communities and celebrating America's hidden stories, bringing to life the people, places, and events from the past. To discover the history of other communities across the nation, please visit:

www.arcadiapublishing.com

Customized search tools allow you to find regional history books about the town where you grew up, the cities where your friends and family live, the town where your parents met, or even that retirement spot you've been dreaming about.